You can Draw

pets

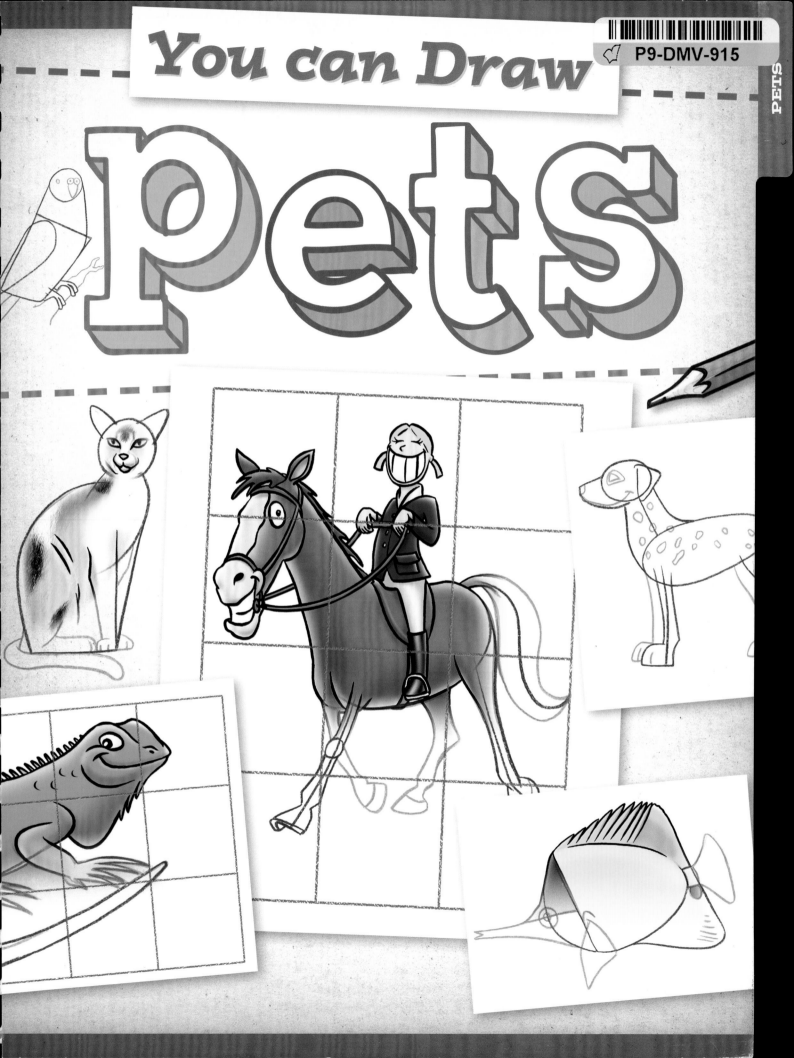

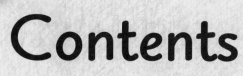

Contents

Introduction

Drawing is a fun and rewarding hobby for children and adults alike. This book is designed to show how easy it is to draw great pictures by building them in simple stages.

What you will need

Only basic materials are required for effective drawing. These are:

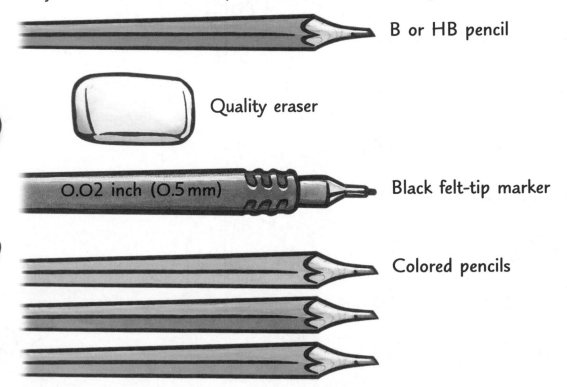

B or HB pencil

Quality eraser

0.02 inch (0.5mm) Black felt-tip marker

Colored pencils

These will be enough to get started. Avoid buying the cheapest pencils. Their leads often break off in the sharpener, even before they can be used. The leads are also generally too hard, making them difficult to see on the page.

Cheap erasers also cause problems by smudging rather than erasing. This often leaves a permanent stain on the paper. By spending a little more on art supplies in these areas, problems such as these can be avoided.

When purchasing a black marker, choose one to suit the size of your drawings. If you draw on a large scale, a thick felt-tip marker may be necessary. If you draw on a medium scale, a medium-point marker will do and if on a small scale, a 0.01 inch (0.3mm), 0.02 inch (0.5mm), 0.027 inch (0.7mm), or 0.03 inch (0.8mm) felt-tip marker will be best.

The stages

Simply follow the lines drawn in orange on each stage using your B or HB pencil. The blue lines on each stage show what has already been drawn in the previous stages.

1.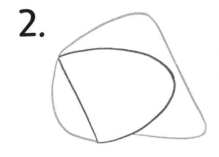

2.

3.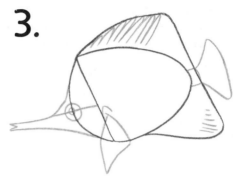

In the final stage the drawing has been outlined in black and the simple shape and wire-frame lines erased. The shapes are only there to help us build the picture. We finish the picture by drawing over the parts we need to make it look like our subject with the black marker, and then erasing all the simple shape lines.

4.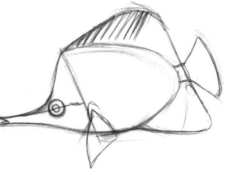

Included here is a sketch of the butterfly fish as it would be originally drawn by an artist.

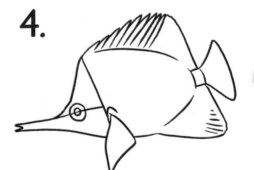

These are how all the drawings in this book were originally worked out and drawn. The orange and blue stages you see above are just a simplified version of this process. The drawing here has been made by many quick pencil strokes working over each other to make the line curve smoothly. It does not matter how messy it is as long as the artist knows the general direction of the line to follow with the black marker at the end.

The pencil lines are erased and a clean outline is left. Therefore, do not be afraid to make a little mess with your B or HB pencil, as long as you do not press so hard that you cannot erase it later.

Grids made of squares are set behind each stage in this book. Make sure to draw a grid lightly on your page so it does not press into the paper and show up after being erased. Artist tips have also been added to show you some simple things that can make your drawing look great. Have fun!

The Parakeet

The parakeet is the most popular pet bird in the world. It can be trained to learn words and repeat them in proper sequence. Parakeets are an Australian native bird, however the first captive breeding took place in Europe in the 1850s.

1.

Draw a grid with three equal squares going across and four going down.

Begin with a circle near the top of the grid. Be sure to draw it in the correct position.

Draw a body shape that looks a little like a rectangle that is slightly curved on the bottom and smaller at one end.

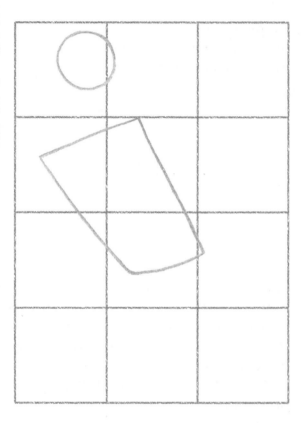

2.

Connect the head to the body with straight lines. Notice how the chest of the bird bends just inside the rectangle. This is to eliminate a sharp bend. Draw in the shape for the wing.

Draw the claws. The further set of claws appear above the nearer set. Check your drawing and move on to the next stage.

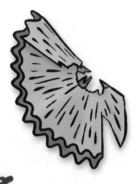

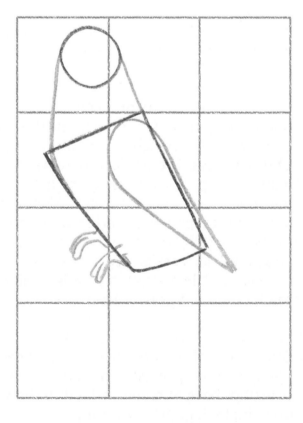

3.

Draw in the beak to the left of the head circle and the eye to the right of the head circle.

Draw in a branch for the parakeet to be holding onto. Starting from the back of the rectangle shape for the body, add a long slightly curved shape that comes to a rounded point for the tail feathers.

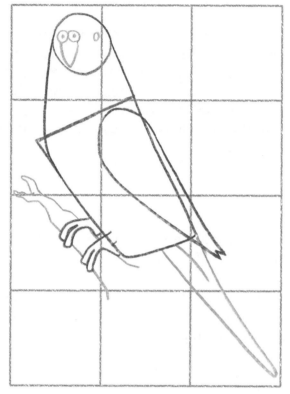

4.

Outline your artwork and erase the pencil lines. Parakeets come in many different shades and patterns. You could add your own pattern. Be sure to do it with pencil though, as too much black marker will darken the picture, making it look heavy.

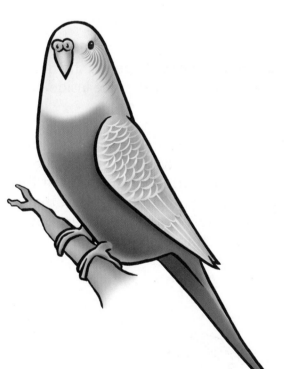

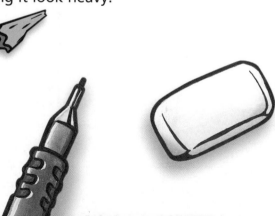

The Cat

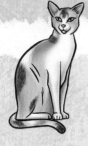

With around 100 different breeds, domestic cats come in many shapes and shades. They are very light-footed and are able to leap seven times their body height upward. All that exercise makes them tired and they rest about 17 hours a day.

1.

Draw a grid with three equal squares going across and four down.

Begin by drawing the shape for the body. It is basically a backward "L" with a big long curve joining the ends together.

Draw the head circle above and to the right of the body shape.

2.

Add some pointed shapes to the head shape for the ears. Draw a small circle inside and near the bottom of the head circle.

Draw an oval leaning on an angle under the head circle. This will become the chest. Join the chest to the bottom right corner of the body shape with a straight line. Check that everything on your drawing is in the correct position and move on to the next stage.

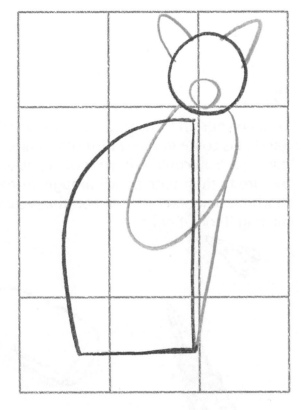

3.

Draw leaf shapes for eyes inside the head circle and add the pupils. Draw a nose near the top of the small circle inside the head circle. Notice the mouth is a "W" shape.

Draw some lines to show the back leg curving and add in the back foot. Draw a line for the front leg and paw at the bottom. Add the other front paw outside the body shape. Draw in the back of the rear foot and the tail curving around.

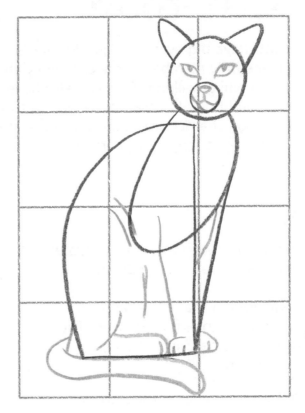

4.

Outline your cat and erase the pencil lines. Cats come in many different shapes and shades. You may like to try some different shades and patterns.

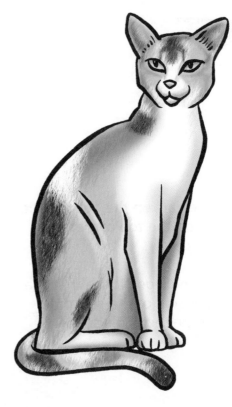

Cat-toon

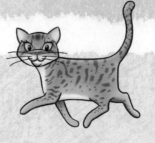

Cats have big eyes and squarish bodies. The domestic cat is the only member of the cat family able to hold its tail high while walking. They can also have a wide head. By highlighting all these points we can turn our cat into a fun cartoon character. The more exaggerated the features, the more "cartoony" the character.

1.

Draw a grid with four equal squares going across and three down.

Begin with a shape like an over-inflated football for the head. The top side bulges more than the bottom side.

Draw a rectangle at the bottom right side of this for the body.

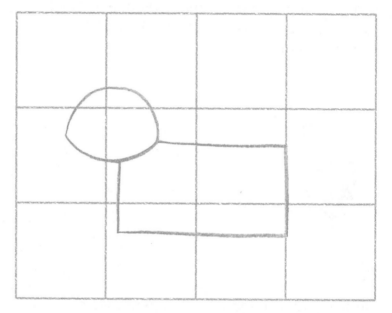

2.

Draw some ears on the head shape. Add a tail on the top corner of the rectangle.

Draw in some legs. Notice that the legs on this side of the cat come right into the rectangle shape.

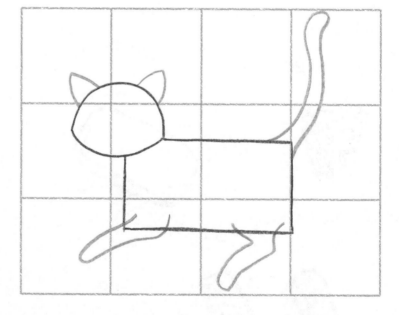

3.

Draw in the face and neck. The bigger the eyes, the cuter the look for the character. Here we have rather large eyes.

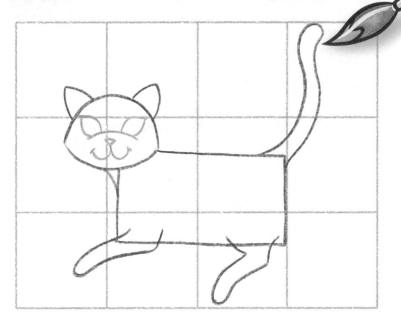

4.

Draw big pupils in the eyes and draw the chin under the mouth.

Draw the legs on the other side of the body.

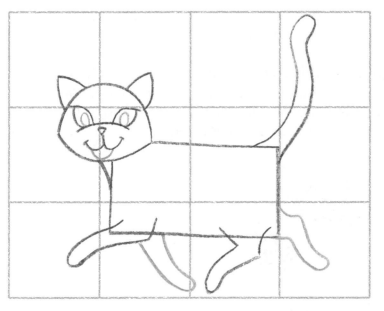

5.

Outline your tabby and erase the pencil lines.

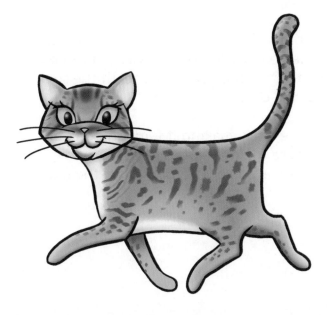

The Horse

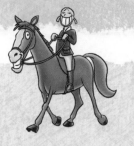

The horse has been our helper for thousands of years. Horses were used for everything from working the fields to general transport. Modern machinery has since replaced most of the duties that horses had to perform. Today the horse is kept for recreation purposes like trail rides and horse shows.

1.

Draw a square grid with three equal squares going across and three down.

Begin with a shape for the body slightly lower than the middle of the grid. Draw a circle for the head at the top left of the grid and join this to the body shape with a line.

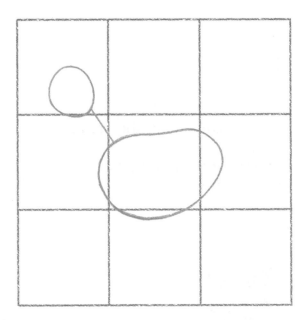

2.

Draw another circle below and slightly to the left of the head circle. Join the circles to make the snout. Draw the part underneath the small circle for the chin.

Draw in the neck, making it fairly thick. Look to see where the neck attaches to the body shape. Draw in some wire-frames for the legs.

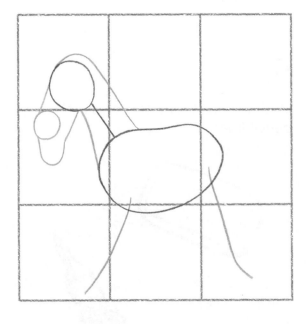

3.

Add the ears and mane to the neck. Draw the horse's eye, mouth, and nose.

Draw in the head and body shape for the girl. Draw one leg over the horse's body shape.

Add a wire-frame for the tail of the horse. Draw in the legs and knees around the leg wire-frames.

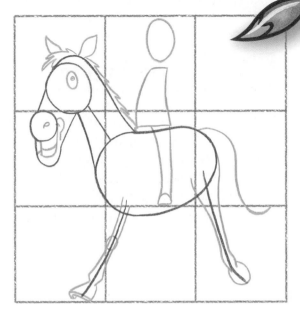

4.

Draw a wavy line for the white patch on the horse's head.

Add the girl's face, arms, hands, and clothes. Draw the reins from her hands to the horse's mouth and around the horse's head.

Draw in the saddle and tail. Draw the legs on the other side of the horse. Notice they do not appear as long as the ones on this side.

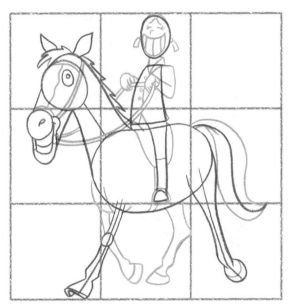

5.

Outline the drawing with your marker and erase the pencil lines. This picture is quite complicated, but with a little practice this drawing technique will become second nature.

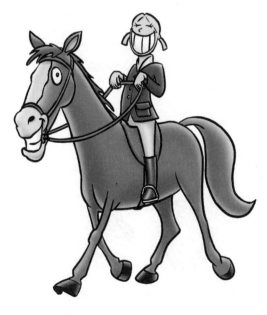

Dalmatian

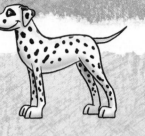

The Dalmatian is a large, friendly, intelligent, and energetic dog. They were originally bred for show. They would run ahead of carriages pulled by horses. They also guarded the horses in the stables when they were resting. Dalmatians are easily identified by their black spots. They are actually born white and do not get their spots until later in life.

1.

Draw a grid with four equal squares going across and three down.

Start with an oval for the body shape. Notice that this oval is on an angle and is smaller at one end.

2.

Draw in a circle for the head and join it to the body with a wire-frame.

Add some wire-frames for legs. The back leg is curved.

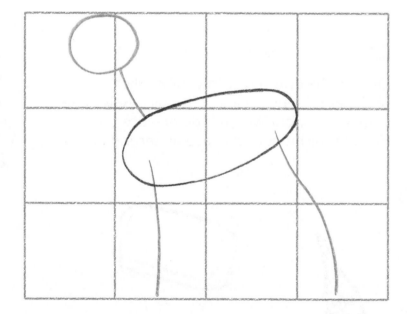

3.

Draw a snout on the head circle and a triangular ear at the back of the head circle.

Draw a sharp tail at the end of the body shape. Draw legs around the wire-frames with lumps for paws at the bottom.

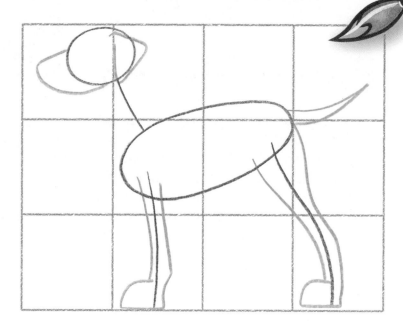

4.

Draw the mouth, eye, and eye patch. The eye and eye patch are also triangle shaped. Add spots to the body.

Draw in the legs on the other side of the body, making them a little shorter. Divide up the paws with some curved lines to form toes.

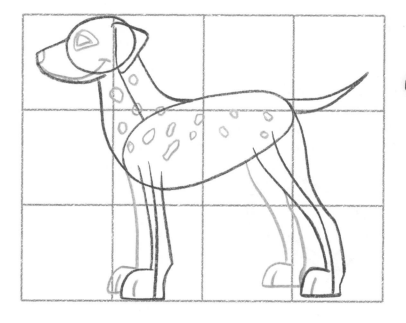

5.

Outline your dalmatian with your marker and erase the pencil lines. Dalmatians are white but can be shaded with a gray or black pencil. Notice the shading under the belly and inside the legs.

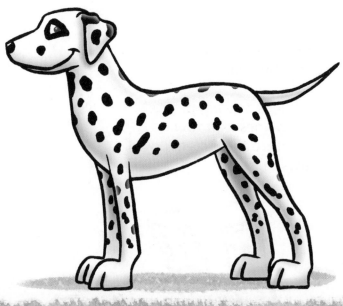

Basset Hound

The Basset Hound is a short, large-bodied dog. They were originally bred in England for hunting. With their small legs they could squeeze their way through places larger dogs could not go. Their strong sense of smell meant they could track animals very well. Basset Hounds love companionship and have lots of personality. They are patient and good with children.

1.

Draw a grid with four equal squares going across and two down.

Begin with a shape like a jelly bean for the body and a circle for the head.

2.

Add a large shape for the dog's snout onto the head shape.

Draw thick legs and big paws. The back leg lines lean toward the right before they travel down to the paws.

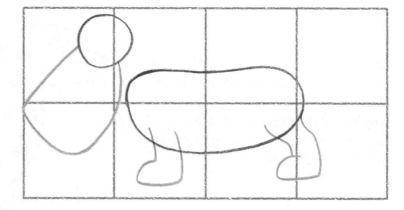

3.

Draw on the neck, joining the head circle and snout to the body.

Draw in the bent, pointed tail. Add the legs on the other side of the body, making them a little smaller than the ones on this side.

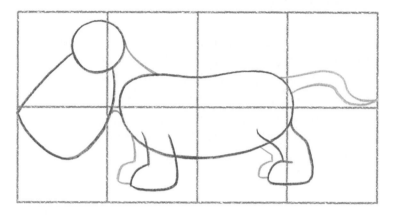

4.

Finally, draw the facial features. A Basset Hound has half-closed eyes with lots of droopy skin underneath them. Add a big smile and some long ears that reach to the ground.

Draw some lines to break up the paws.

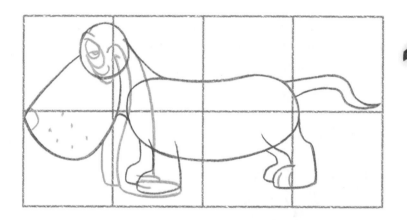

5.

Outline your work and erase the pencil lines. When shading in, you may like to try different patches around the body.

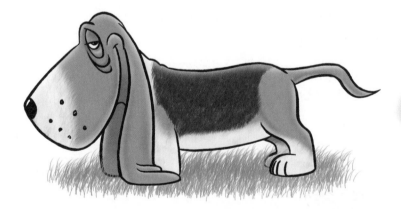

Guinea Pig

Guinea Pigs are very small and furry creatures. They are quite timid and often scurry away to hide as they get frightened easily. They have large front teeth. Their teeth never stop growing so they must constantly gnaw on things to wear them down. Guinea Pigs live on vegetables and eat quite a lot. Maybe that is where they got the name "Pigs."

1.

Draw a grid with four equal squares going across and three down.

Draw an oval shape to the right of the grid. This will form most of the bulk of the body.

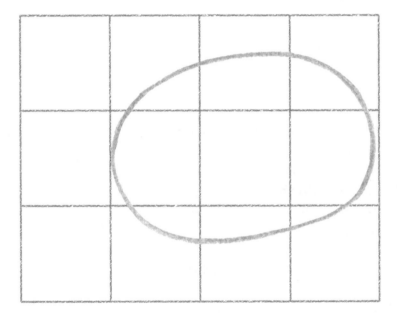

2.

Draw in the more pointed shaped line for the head.

Draw a little lump on the bottom rear of the body shape for the back leg.

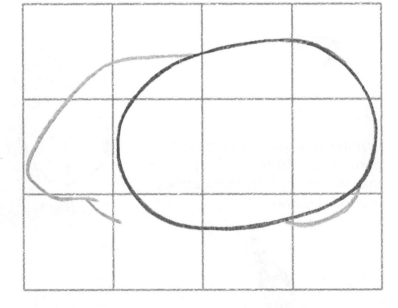

3.

Add the ears, eye, and a stretched "V" shape for the nose.

Draw the front legs, making the one further away a little smaller than the one closer to us.

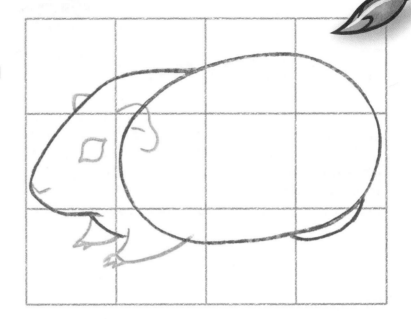

4.

Add the patch around the eye. Draw in a line to show the back of the pupil in the eye. Draw in the front of the ear.

Add some little strokes to show where the coat hair changes shade. Add some little claws to the back foot.

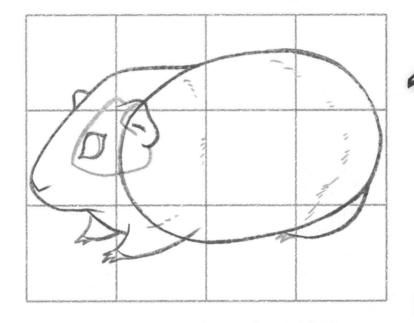

5.

Outline your artwork and erase the pencil lines. Shade your guinea pig.

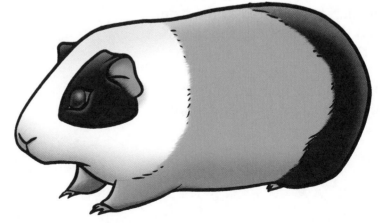

The Iguana

Iguanas are reptiles. They hatch from an egg and can grow to be the length of a human adult. They are cold-blooded and must spend time in the sun to warm up. They do not respond to owners' commands like other pets. They prefer to be in a quiet and calm environment. Iguanas are able to live with other animals, but they are not playful.

1.

Draw a grid with four equal squares going across and three down.

First, draw in an oval on an angle for the body. This oval is slightly larger at the front.

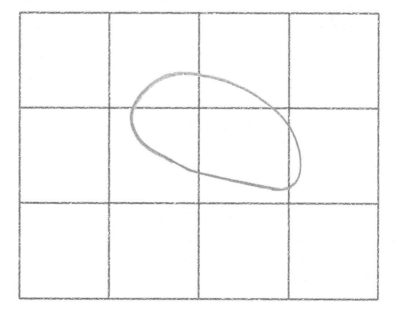

2.

Draw a head shape that is mostly circular, but pointed at the front. Join this to the body shape with a wire-frame.

Draw a long, pointed tail coming off the back of the body shape.

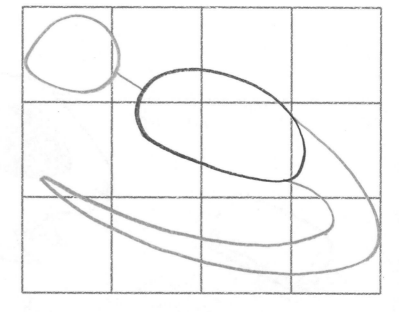

3.

Draw the face within the head shape. Add a triangular flap under the chin. Draw in the back of the neck.

Draw a line from the top of the head to the tail above the neck and body shape. Draw the individual spines on its back to this height. Add the legs and the feet.

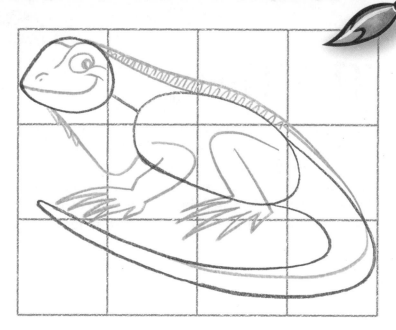

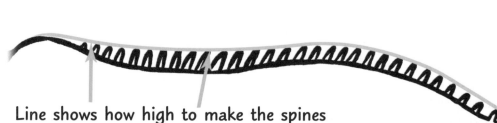

Line shows how high to make the spines

As the line gets closer to the body, the spines gradually get smaller

Artist Tip:

Like our basic shapes, sometimes lines are used just as a guide. The line drawn above the neck that runs down to the tail is only there to show us how high the spines on the back should be. With this line as a height guide, we can simply draw the spines straight up to this height and know that when the line is erased, the drawing will look correct.

4.

Outline your iguana, erase the pencil lines and color.

The Turtle

Turtles make great pets. They can be kept in a tank that is half water and half dry soil, rocks, or sand. Some turtles can breathe under water and some need to come to the surface to take in air. Turtles need some sunlight for their shells to harden. They shed their shell as they grow. Female turtles are generally larger than male turtles but males have longer tails.

1.

Draw a grid with four equal squares going across and three down.

Draw an angled oval shape for the head on the left side of the grid. Check that it is in the correct position before going on to stage two.

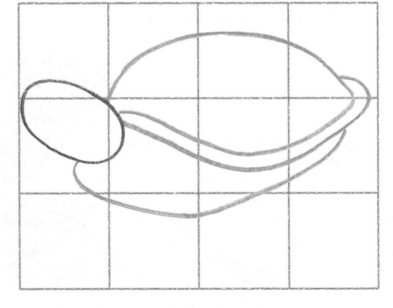

2.

Draw in a big arc for the top of the shell. Draw a dipped double line for the shell edge. Draw a line for the under shell.

3.

Draw a smile on the lower part of the head circle and an eye above the smile.

Divide the shell into squares stretched across the shell top. Draw in the flippers and lines for the top of the under shell.

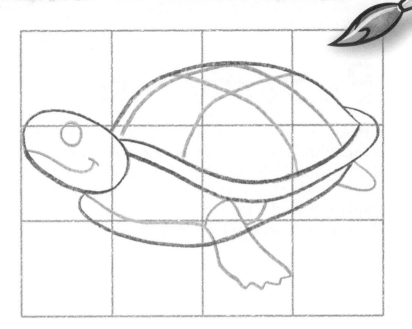

4.

Draw the eye and some lines around it. Add the neck.

Draw in the flipper on the far side. Add a few shapes for the patterns on the flippers, neck, and shell top.

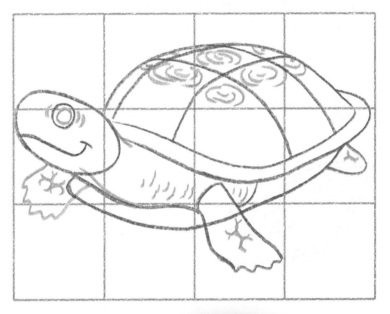

5.

Outline your turtle with your marker and erase the pencil lines. Fill in your drawing with greens and yellows.

Butterfly Fish

The Long Nose Butterfly Fish is found in warm tropical waters around coral reefs. It uses its long nose to pick at food pieces between delicate branches of coral where other fish cannot reach. It is a carnivore, which means it only eats meat. Its preferred food is small crustaceans. It is a gentle fish that can be kept as a pet in saltwater aquariums.

1.

Draw a grid with four equal squares going across and three down.

Begin with a shape that looks like the letter "D" leaning backward. This will make up the bulk of the body.

2.

Draw a curve around the front of the "D."

Add another line behind the "D" that has round but sharper corners. Notice where it attaches to the body underneath.

3.

Add a long snout and an eye onto the front of the curve. Divide the head lengthways above the long nose with a straight line.

Add the fin, tail fin, and a circle under the tail fin. Divide the top fin into individual spines placed almost to the corner. Draw lines for the bottom fin at the rear.

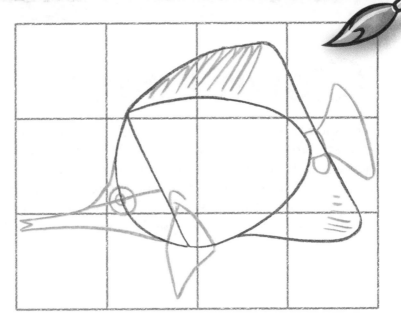

Artist Tip:

Shading can make a drawing look three dimensional. Shading is generally the underside of something where it is not in direct sunlight. When shading, use a darker hue of the same color. Here a dark yellow has been used for the shading on the lower part of the body, which curves under.

Normal yellow

Shaded with a darker yellow on the underside

4.

Outline your drawing and erase the pencil lines. The colors are very definite on this fish. Use black and white for the head and yellow for the body.

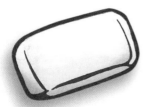

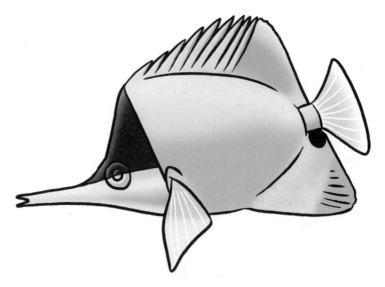

Clown Loach

The Clown Loach is a freshwater fish. They live in a tropical climate where the water is warm. The Clown Loach eats a variety of foods including worms, crustaceans, and plants. Because of their pattern they are a very popular fish for aquariums. They are a timid fish and like to have members of the same species in tanks with them.

1.

Draw a grid with four equal squares going across and two down.

Begin with a shape in the middle of the grid. This will represent the loach's body.

2.

Add a more pointed front to the fish's face for the mouth.

Draw the fins around the body. Notice where the fins are in relation to the body shape. They are further back than you might think.

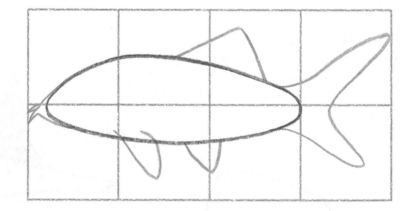

3.

Draw in the mouth and the eye shape. Draw a band around the body. Divide up the top fin with some strokes for spines.

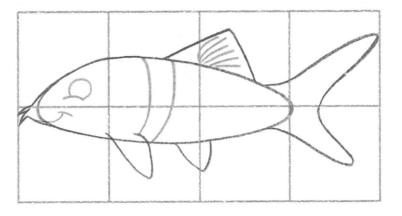

4.

Add the rest of the bands around the body.

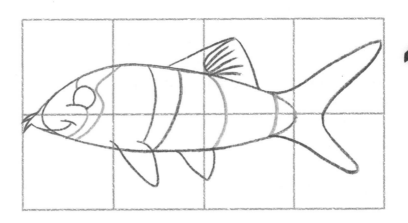

5.

Outline your work and erase the pencil lines. Fill in your drawing with black, yellow and orange, adding detail to the fins and tail.

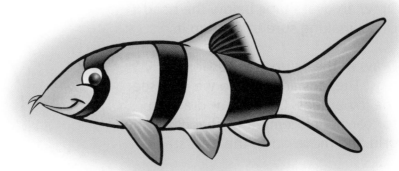

Chimpanzee

Chimps live in trees and are found in family groups. Many of these family groups living together make up a community. Chimps communicate with facial expressions and by clapping their hands. They do not have tails like monkeys but they do have large ears. They eat fruit, leaves, flowers, and insects and will sometimes hunt other animals for meat. Some chimps live in sanctuaries where families can "adopt" them, providing money for their food and care.

1.

Draw a square grid with three equal squares going across and down.

Draw a circle left of the middle of the top of the grid for the head. Draw a big arc going from one side of the grid to the other with a flat bottom. This is the overall shape of the chimp.

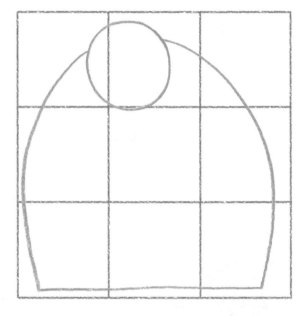

2.

Draw an oval shape below the head circle, making sure to overlap it.

Draw in the "club" shapes for the legs. The legs are bent so we only see the lower legs. Check your drawing for correct placement of shapes on the grid and move on to the next stage.

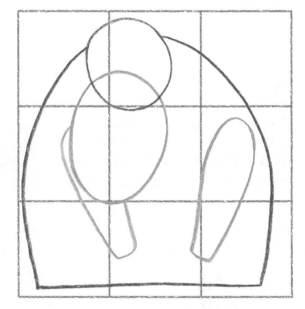

3.

Some details can now be added. Start with the eyebrow, which overlaps the head. The mouth divides the bottom circle in half and the lips stick out of the circle.

Draw in the lines for the arms on either side of the arc. Finish this stage by drawing in shapes for the feet.

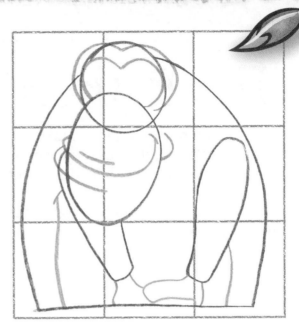

4.

Draw large ears on either side of the head. Put in the eyes and nose. The upper lip is divided with a line down the middle.

Draw in the top of the arm on the right and the legs near the stomach. Add the hands and lines for the buttocks. Divide the feet up into toes and get your felt-tip marker ready to outline.

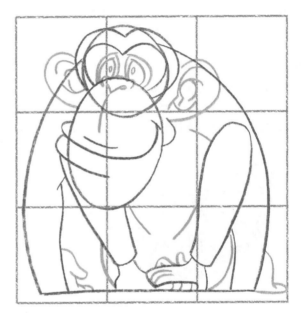

5.

Chimps have dark brown or black fur. Here the fur is black with a blue/gray highlight on it as a shine. The stomach, hands, and face do not have hair on them.

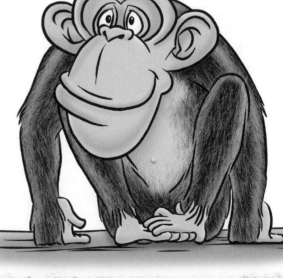

The Python

Pythons are non-venomous snakes that constrict their prey. They wrap themselves around their catch and squeeze until there is no breath left in it. They then unhinge their jaw and eat their prey whole. Pythons are very good swimmers. They spend a lot of their time in the water. Pythons can live for up to 30 years.

1.

Draw a grid with four equal squares going across and three down.

Begin with a wavy line. This line is a wire-frame that the entire body will be based around. It is just like the snake's backbone.

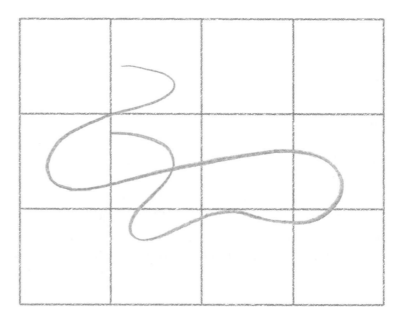

2.

Draw in the snake's body around the wire-frame, making sure to make it fairly thick but parallel to the wire-frame.

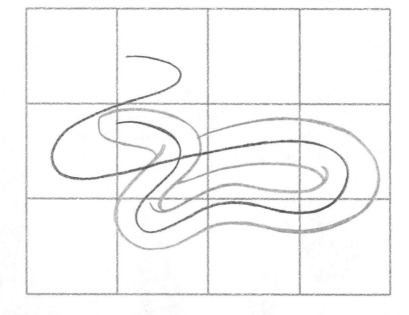

3.

Add the back of the body, gradually getting thinner to a pointed but rounded tail tip.

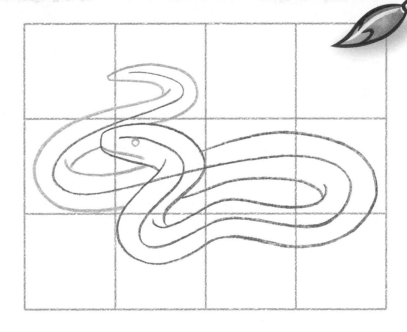

4.

Draw the body pattern around the snake. See if you can make the pattern look like it is on the snake's back.

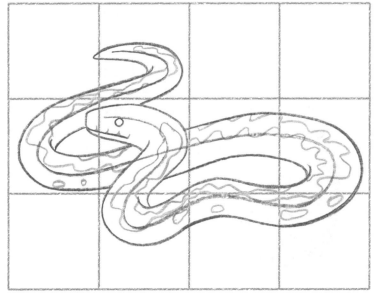

5.

Outline your drawing and erase the pencil lines. The snake is tan with a brown pattern. The pattern has black on its edges.

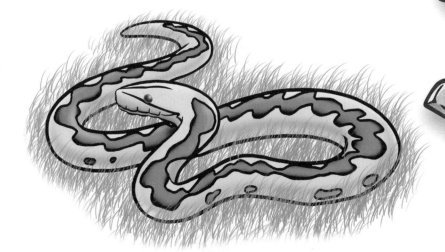

The Mouse

Mice are small, friendly pets. They are cheap and easy to care for. They like to be around other mice and have toys to play with. Like Guinea Pigs, their teeth never stop growing so they gnaw on things to wear them down. Mice will eat almost anything. They reproduce very quickly. A female can have 100 babies in a year.

1.

Draw a square grid with three equal squares going across and down.

Begin with a circle for the head in the correct position on the grid. Draw in a rectangle with rounded edges for the body shape.

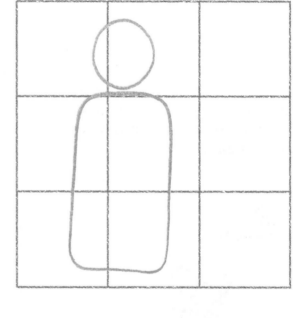

2.

Add another circular shape for the ear on top of the head. Draw an extra shape coming out of the head circle for the snout. Join the head circle to the body shape.

Draw in some shapes for the legs either side of the bottom of the rectangle.

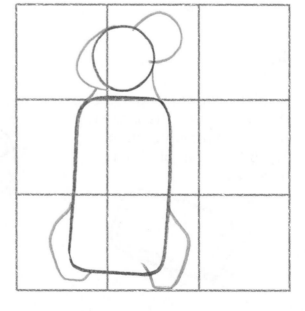

3.

Draw the "V" shaped nose and cheeks that turn into the smiling mouth.

Draw in the eye. Draw in the far ear and inner ear on this side. Add the tiny feet and the line for the tail.

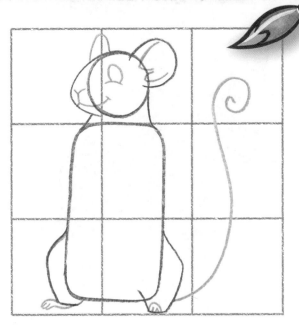

4.

Add the pupil of the eye. Draw the arms and hands holding the cheese. Add the other side of the tail, bringing it to a rounded point.

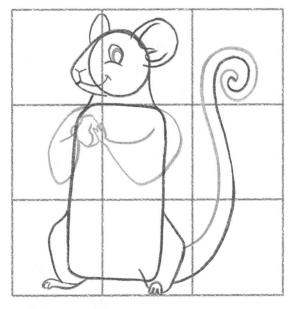

5.

Once you have outlined the picture and erased the pencil, put in a few selective whiskers coming from the whisker spots. Do not put too many in as it will darken the drawing too much.

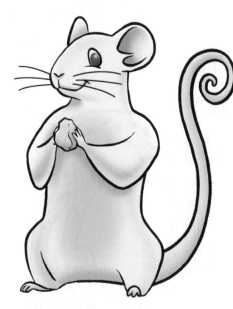

You can Draw
Sea Creatures

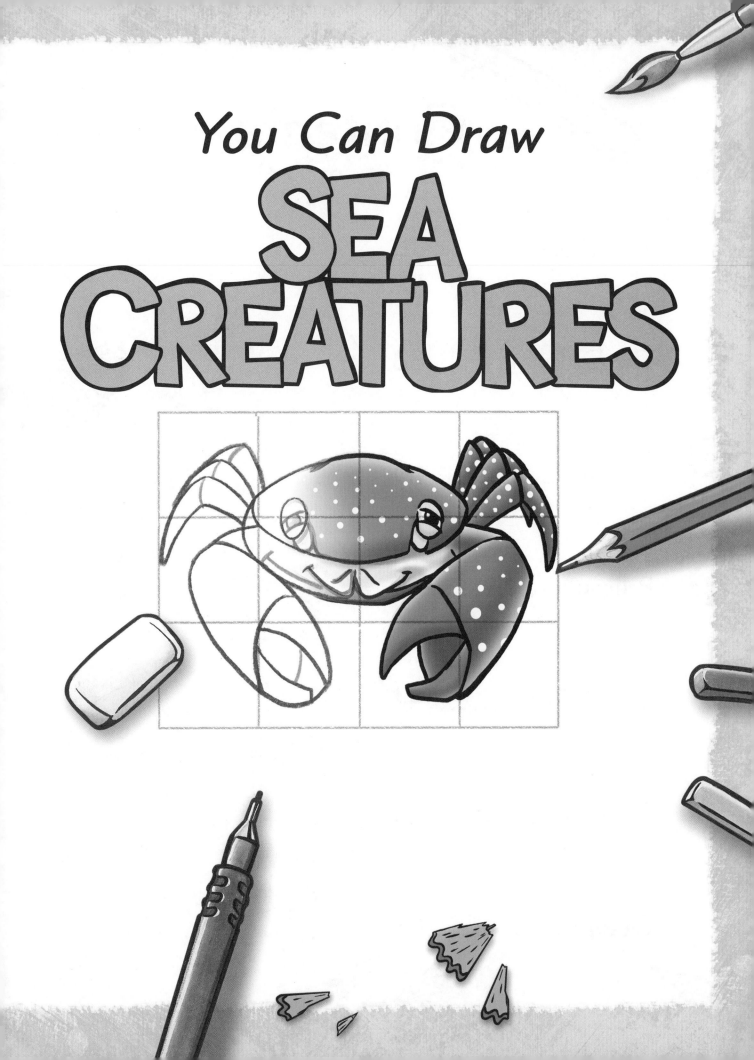

Contents

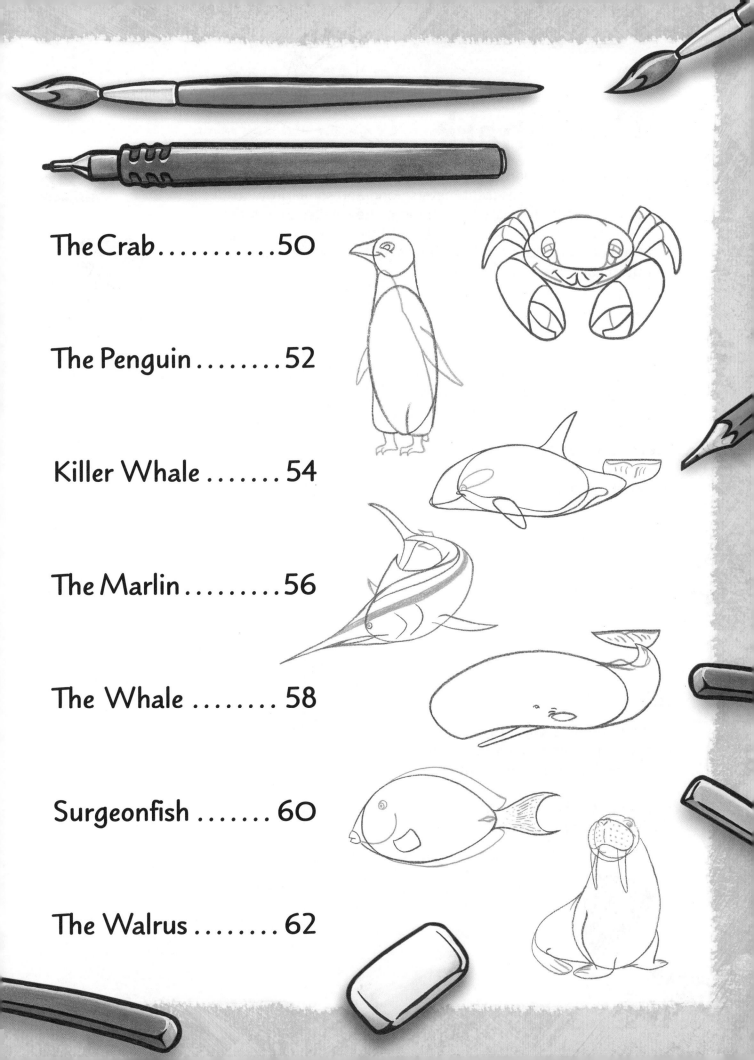

The Shark

Sharks are fish. There are over 300 varieties of shark. Some are only a few inches (centimeters) long and some grow to be over twenty feet (six meters) long. The smaller sharks eat plankton while the bigger sharks eat fish, squid, octopuses, and seals. Sharks do not have bones, but a skeleton made out of cartilage.

1.

Draw a grid with four equal squares going across and three down.

Draw a pointed egg in the left half of the grid. Notice the angle this egg shape is on.

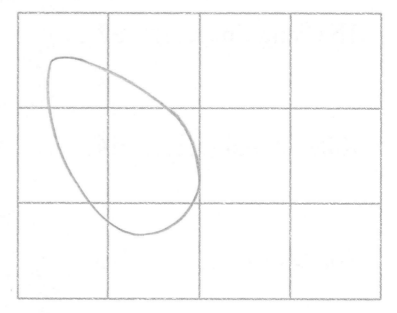

2.

Add a large fin toward the bottom of the egg shape reaching down to the lower left corner of the grid.

Draw a hook that flows off the rear of the egg shape. This will be the shark's lower body.

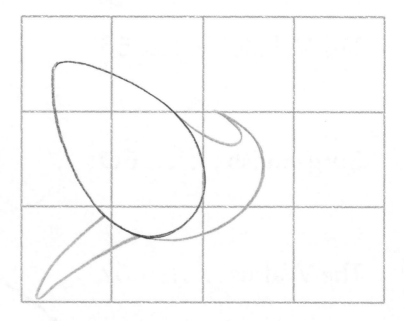

3.

Add the dorsal fin on top of the shark. Be careful to put it in the correct place on the grid. Draw in the four gills near the rear of the egg shape.

Draw the other fin, which goes almost all the way to the right edge of the grid. Add the rear fin behind the right fin.

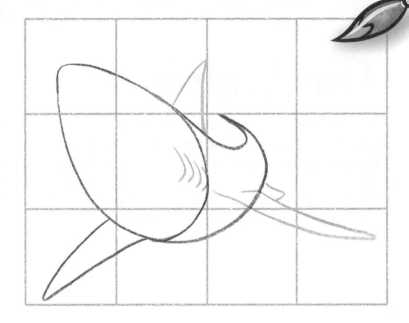

4.

Draw a curved line from the nose to the top of the first gill. Then draw a small line from the bottom of the last gill to the right fin, and from the right fin around the body. This will separate the shades when you fill in.

Draw two spots for the nose. Draw in the eye. Put in a shape like an upside down moon for the mouth and add teeth to the top and bottom.

Draw the tall tail and bottom section behind the dorsal fin.

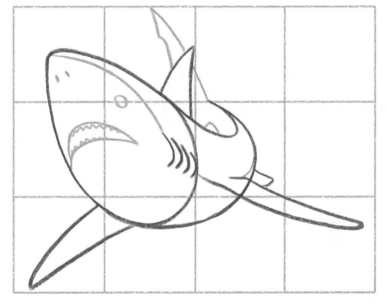

5.

Outline your shark and erase the pencil. You can make your shark gray, dark green, or blue.

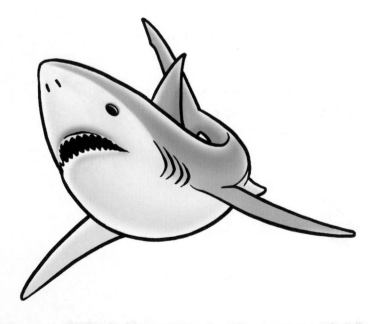

The Dolphin

The dolphin is a member of the whale family. They are warm-blooded and breathe air from the surface. Out of the 30 species of dolphins, the Bottlenose Dolphin is the most common. They live and travel in big groups called pods. Dolphins love to play and will often jump out of the water and perform various flips.

1.

Draw a grid with four equal squares going across and three down.

Draw in the shape for the body of the dolphin. Even though this shape is long, notice how it is stubby at the front and more stretched out at the back.

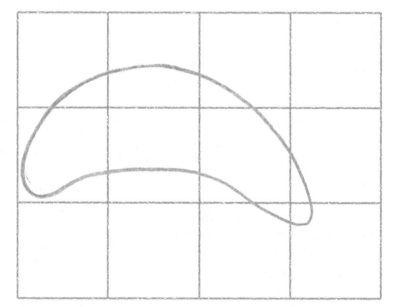

2.

Add the beak at the bottom of the body shape.

Draw a dorsal fin above the right hand side of the middle of the body shape. Add the tail to finish this stage.

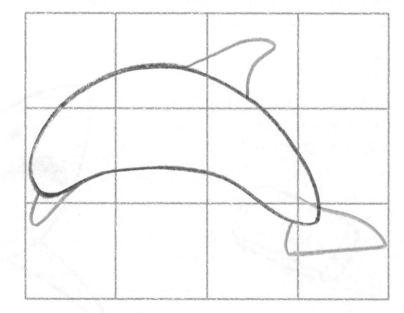

3.

Split the beak shape in half with a line for the mouth. Draw in the eye and cheek top. Add the pectoral fins.

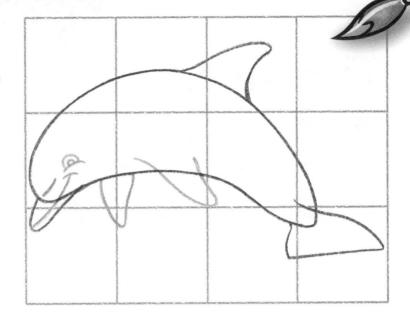

4.

Draw a line along and below the middle of the dolphin's body. Add some water droplets to show that it is leaping out of the water.

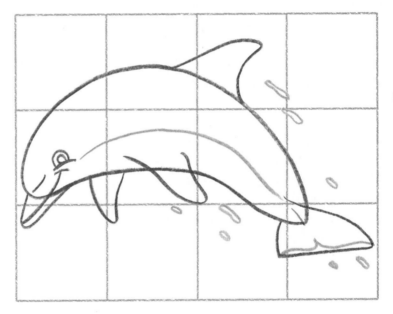

5.

Outline your drawing and erase the pencil lines. I have made this dolphin gray and added highlight points around it to make it look shiny.

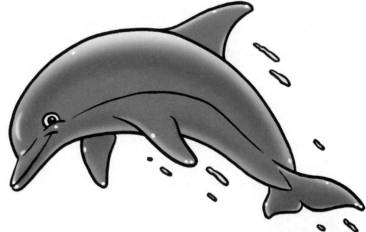

The Turtle

Turtles are cold-blooded and live in the warmer parts of the world's oceans. Turtles do not have feet but have flippers for swimming. Most of a turtle's life is spent in the ocean. They do come to land to lay eggs. On the beach, the female will dig a hole and lay many eggs. When the babies hatch, they make their way straight back to the ocean.

1.

Draw a grid with four equal squares going across and three down.

Draw a circle for the head in the top left square of the grid. Draw in the shape for the shell.

Notice the wire-frame line between the head and the shell. If this line was carried through the head and shell, it would show that the whole drawing is based in this direction.

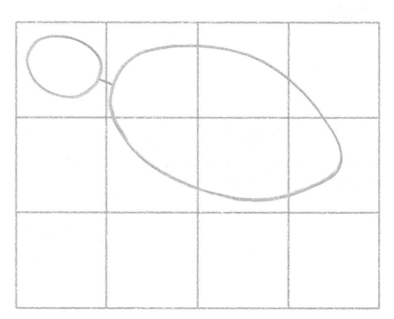

2.

Draw the beak on the head circle. Join the head to the shell at the top. Draw in the neck and large flipper on the underside.

Add the back flippers. Notice the flipper on top is slightly smaller than the one on the bottom.

Draw in the shape for the eye.

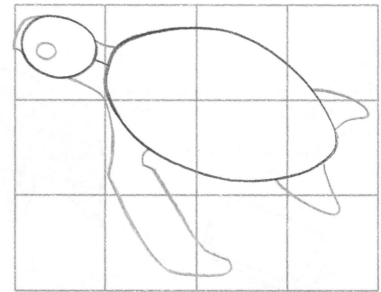

3.

Look closely on the grid to see where the shell pattern falls. The hexagonal shapes are not in the middle of the shell, but are more toward the top side. This makes the shell look three dimensional.

Draw in the leaf-shaped eye to finish this stage.

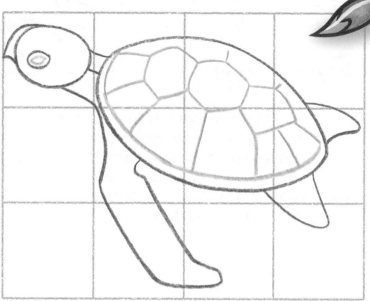

Artist Tip:

The head and flippers have many shapes on them. If we drew them all in with our outline marker, it would darken the picture too much. This is because things in life are rarely completely black. See how dark the drawing to the right is with too many detailed shapes done with an outline marker. When using your marker, try to limit the detail of your subject.

Notice how some of the outlines for the pattern on the turtle's shell do not go right to the edge or meet up with each other. This is another way of limiting detail.

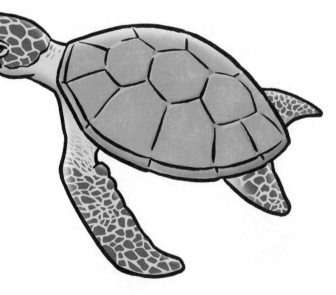

4.

Outline your turtle and fill in. The head and flippers have blue shapes covering them. The shell is mostly green with a little blue lightly mixed in, in patches.

Pelican

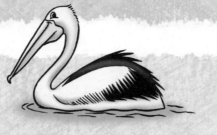

Pelicans are big majestic birds. Their wingspan can reach over six feet (two meters) in length. They also have a very long beak that they use to scoop up fish out of the water to eat. They float very well and have webbed feet for paddling. Pelicans are found in warm parts of the world. They nest in trees and sometimes on the ground.

1.

Draw a grid with four equal squares going across and three down.

Study the shape for the body. It has a long slope going up and a shorter steeper slope going down. Draw this in on the correct place on your grid.

2.

Draw the shape for the wing inside the body shape.

Draw a shape for the head near the top of the grid. Draw two curved lines for the neck, merging it into the body.

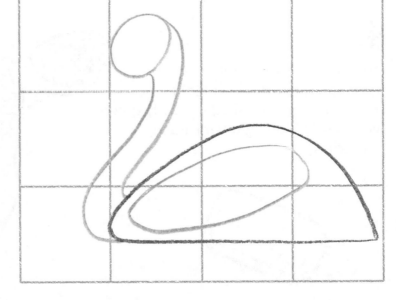

3.

Add the beak onto the head shape. Draw in the eye and whiskers on the back of the head.

Draw a zig-zag line and some straight lines for the feathers on the bottom of the wing shape.

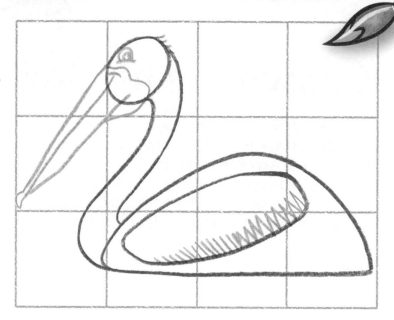

4.

Draw the jagged lines on its back for the rough feathers. Add some more jagged lines going across from the wing to the rear of the body.

Put in some water ripples to finish this stage.

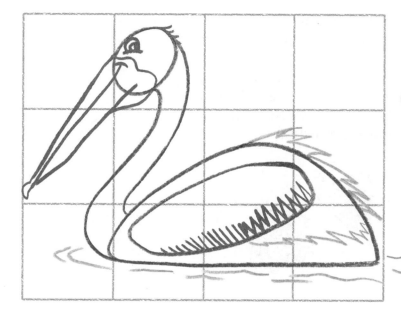

5.

Outline your pelican and erase the pencil lines. Most pelicans are black and white. I have used a gray pencil to shade some of the white areas.

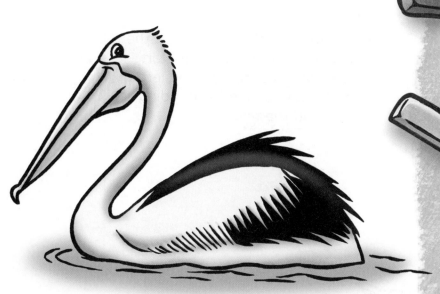

Clown Fish

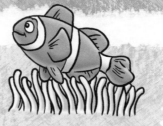

There are many different types of clown fish. This is the
Percula Clown Fish, which is the most well known. They live
in tropical areas of the world where the water is warm. The
clown fish's friend is the anemone. It has long tentacles that
the clown fish hides in. These tentacles kill and eat other
fish but the clown fish has built up an immunity to its sting.

1.

Draw a grid with four equal squares
going across and three down.

Draw in an oval shape that is
pointier at the rear. Make sure
the oval is slanted in an
upward direction.

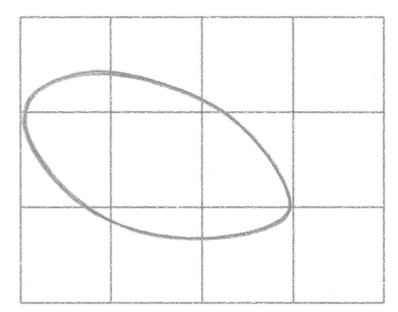

2.

Add on the dorsal fins on top of the
body shape. Notice how they start
in the second square from the left of
the grid. Draw on the surrounding
fins and add the tail.

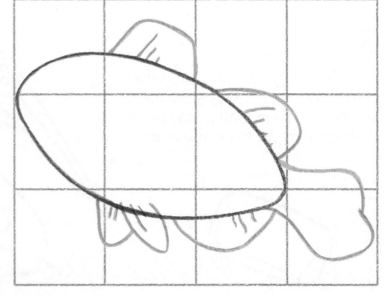

3.

Draw a mouth that looks like a stretched "S" on its side. Draw in the eye and add a curved line above it for the brow.

Add the pectoral fin in the middle of the body. Note the large size of the pectoral fin.

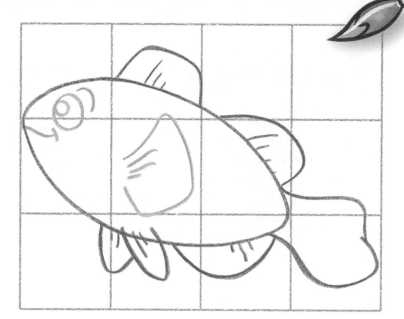

4.

Add three stripes. These surround the head, fall behind the dorsal fins, and circle the tail.

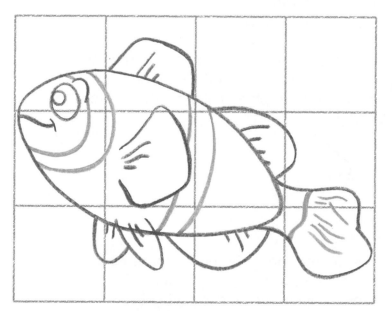

5.

Outline your artwork and erase the pencil lines. Use orange to fill in your clown fish.

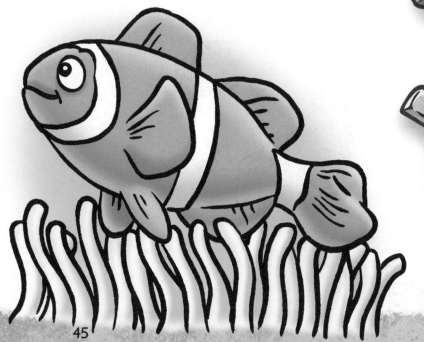

Seahorse

Seahorses are fish. They do not have scales but have skin stretched over their bony skeleton. Seahorses are found in the shallow, warmer parts of the ocean. The fin located on their back propels them through the water in a standing position.

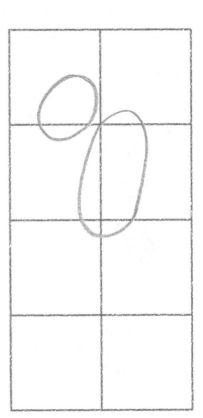

1.

Draw a grid with two equal squares going across and four down.

First, draw the oval-shaped head in the top left of the grid. Draw in the body shape, being careful to place it slightly slanted to the right.

2.

Draw on the snout and neck. Notice how they flow onto the head and body shape. Draw in the twisting tail.

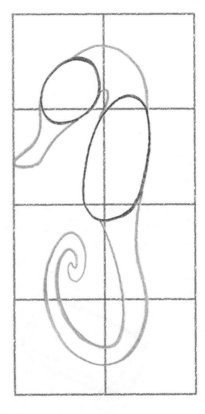

3.

Add the shape on top of the head and the points on the back, running from the top of the neck to the tip of the tail. Draw in the eye and pupil.

Draw slightly curved lines going horizontally across the body of the seahorse from the neck to the end of the tail. These represent the bony skeleton.

Draw a line down the length of the seahorse, curved between each previously drawn horizontal skeletal line. Add another vertical line toward the front of its body.

Draw in the little fin underneath the belly and the large fin on the back.

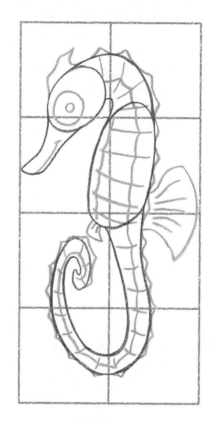

4.

Outline your drawing and erase the pencil. Seahorses come in many different shades and patterns. You may like to try making up your own pattern.

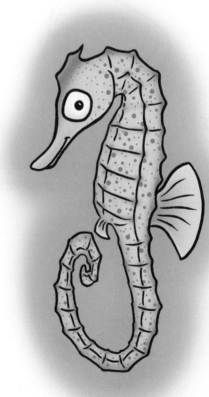

Octopus

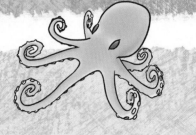

The octopus is a master of disguise. It can change its color to mirror its surroundings so it cannot be seen. This camouflage helps it hide from predators. It has great eyesight and can squeeze through very small gaps between rocks to escape.

1.

Draw a grid with four equal squares going across and three down.

Draw a shape for the head in the top right side of the grid. Draw another shape slightly smaller under this for the body.

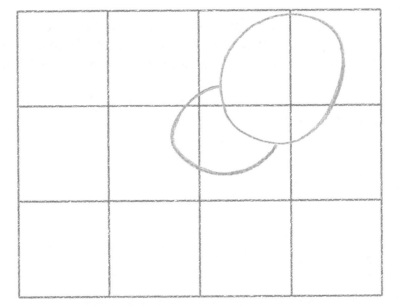

2.

Draw in some curved lines for legs. Be careful to note how and where they fall on the grid.

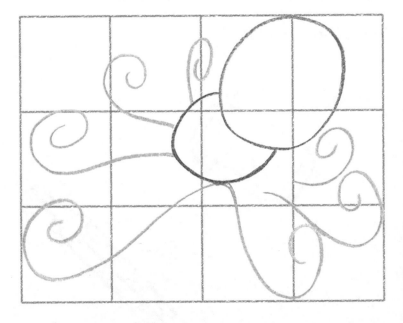

3.

Draw in the top side of the legs, bringing the tips to a point.

Add the eyes. One of them is outside the head shape and one is inside the head shape. Make the head a little pointier.

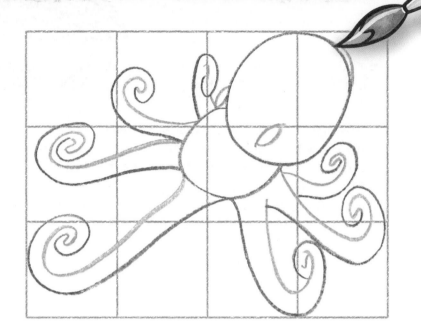

4.

Add some suckers to the underside of the legs.

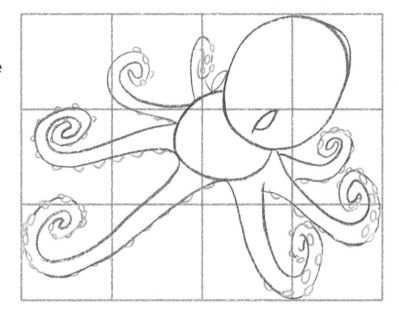

5.

Outline your octopus with your marker and erase the pencil lines. You can make your octopus any color you like as they can mimic every color.

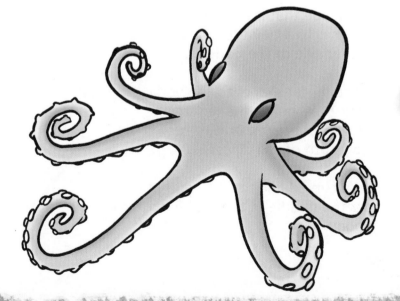

The Crab

Crabs are ten-legged crustaceans that walk sideways. They have two large claws called pincers that they use for feeding or to defend themselves if necessary. All their bones are on the outside. This is called an exoskeleton. There are more than 5000 species of crabs. Some live in the ocean and some live on land.

1.

Draw a grid with four equal squares going across and three down.

First, draw in an oval for the crab's body. Draw in two more shapes pointing down and toward the middle of the grid. These will be the pincers.

2.

Add a shape that is wide at the top and comes to a point for the legs on either side of the body shape.

Join the pincer shapes to the body at their tops, below the leg shape we have just drawn. Draw a curved line on both of the pincers.

Draw a curved line through and just under the middle of the oval for the body.

3.

Break the legs shapes up into three legs using two lines on each.

Add the eyes above the middle line in the oval body shape. Draw the mouth parts under this line.

Define the pincers.

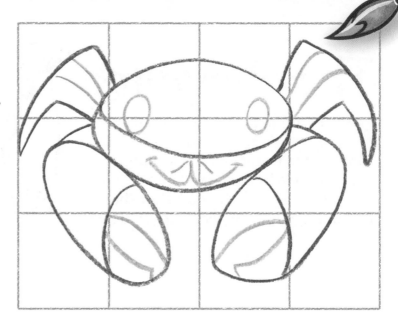

4.

Put joints in on the legs. Draw a small hump at the top of the oval for the body shape. Draw in the parts underneath the eye.

Draw in a line to make the bottom of the shell and pincer arms.

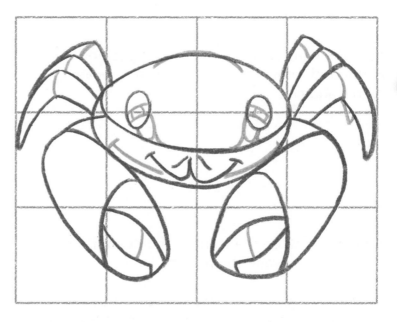

5.

Outline your crab with your marker and erase the pencil lines. Color your crab.

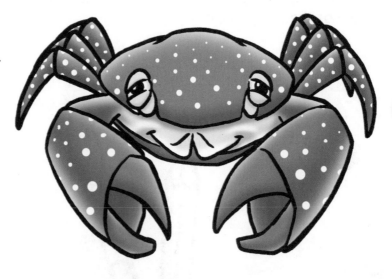

The Penguin

Penguins are birds. They cannot fly through the air but they do "fly" through the water with their flippers. Penguins hatch from eggs like other birds. They are only found below the equator and like to swim in icy cold seas.

1.

Draw a grid with two equal squares going across and four down.

Draw the head shape in the correct position on the grid. Draw the body shape and move on to stage two.

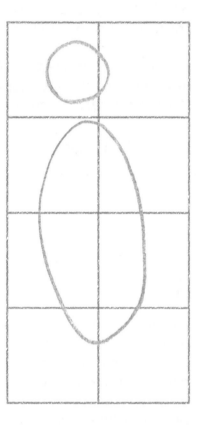

2.

Draw the beak on the front of the head shape. Draw in the eye and the mouth.

Draw in the neck, which flows onto the head and body shapes. Draw the puffy legs at the bottom of the body shape.

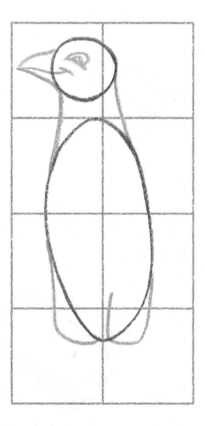

3.

Draw in the flippers (or wings) around the middle of the belly.

Draw a line from the neck to the flipper. Then continue it down to the back of the leg. Draw in the feet and a little bit for the tail.

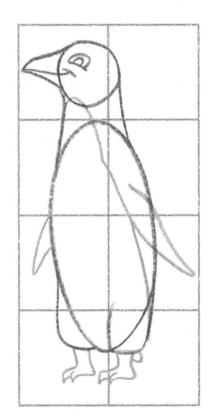

4.

Outline your penguin and use gray to fill it in.

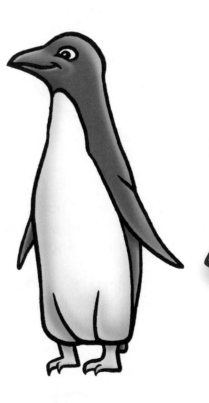

Killer Whale

The killer whale is a large marine mammal that hunts for its prey. They hunt in groups and eat fish, squid, seals, penguins, and other whales. They have a white underbelly and a white patch behind the eye and near the tail. They can grow to over 25 feet (eight meters) long and weigh over three and a half tons. The dorsal fin of a male can reach almost six feet (two meters) tall.

1.

Draw a grid with four equal squares going across and two down.

Begin with a shape on the lower part of the grid. This will represent the killer whale's body.

2.

Draw the pointed but still rounded nose of the whale, being careful to merge it onto the body shape.

Draw the dorsal fin to the rear of the body shape. Add the shape for the rear of the body.

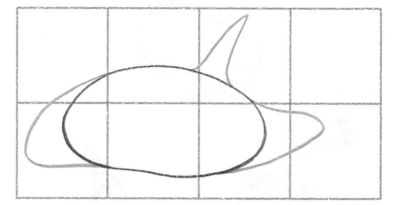

3.

Draw a little lip on the nose of the whale and continue that line for the mouth. Draw the bottom part of the lip and merge it into the nose.

Draw a wavy line through to the rear of the body for the markings. Add the short, stubby flipper.
Draw the tail fin shape.

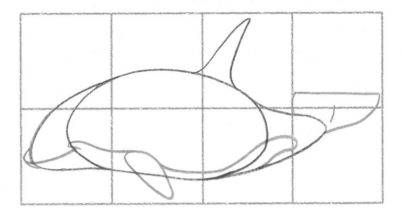

4.

Draw the eye and the marking behind it for the patch of white. Define the tail inside the shape drawn in the last stage.

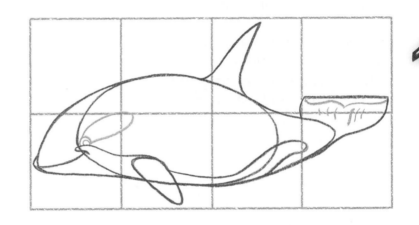

5.

Outline your work and erase the pencil lines. Killer whales are black on top. I have highlighted this to add a three-dimensional look to it. The belly has been shaded with a gray on the underside.

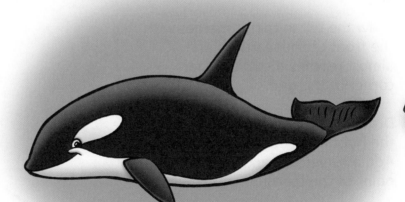

The Marlin

The marlin is a big, fast-swimming fish that lives offshore in deep waters. Marlin eat tuna, which are also very fast swimmers. The marlin has a long bill that it uses to stun the fish once it has caught them. It then turns around and eats them. It will also eat squid and large crustaceans. Marlin grow to be over twelve feet (four meters) long and weigh nearly a ton.

1.

Draw a grid with four equal squares going across and three down.

Begin with a shape that looks like a bent teardrop. Make sure this is positioned correctly on the grid as the bill is long and takes up a lot of room.

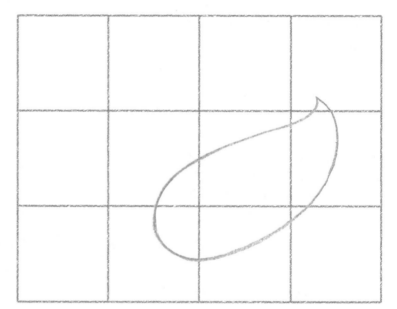

2.

Draw the bill so that it merges with the front of the teardrop and almost reaches the bottom left corner of the grid.

Draw the flipper that reaches to the right hand edge of the grid. Add a curved tail end from the point of the teardrop.

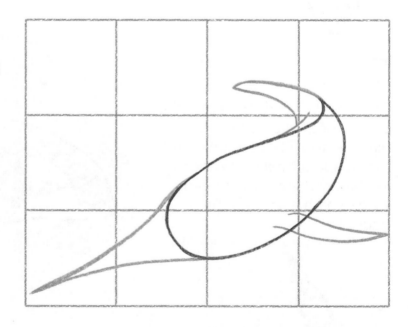

3.

Draw the mouth inside the shape for the bill. Add gill lines behind the mouth.

Draw the dorsal fin near the top of the teardrop, reaching along it to the point. Draw the tail fins on the curved tail section.

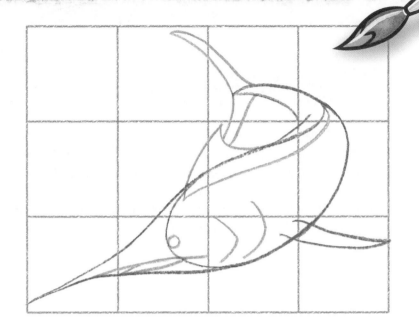

4.

Draw a thick line that stretches from the bill right through to just below the point of the teardrop. Draw in the fin on the other side of the body and the fins near the tail.

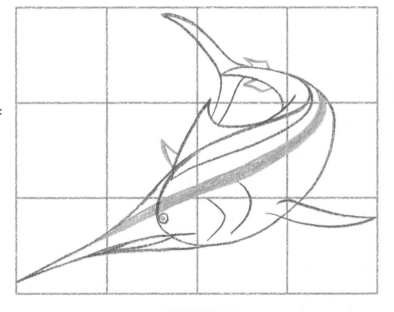

5.

Outline your marlin and erase the pencil lines. Marlin range from green to blue. Their sides and undersides range from white to silver. They have gray stripes that run vertically along the body.

The Whale

This is a sperm whale. The sperm whale is very large and has a distinctive shape. Its nose is flat, not pointed like most whales. It is the largest whale to have teeth and uses these to eat giant squid. Diving very deep in the ocean where it is completely dark, the whale uses sonar to locate its prey. The sperm whale can stay underwater for up to an hour before it needs to breathe again.

1.

Draw a grid with four equal squares going across and two down.

Start with what looks like a stretched jelly bean at the left hand side of the grid. Check that your shape looks just like this one before moving on to the next stage.

2.

Add the bottom jaw below the shape. Notice it starts from around the middle of the first shape. Draw in the eye slightly to the right and above it.

Draw in the fin and a hook shape for the lower end of its body. Draw in the bottom of a semi-circle capped with a line for the tail.

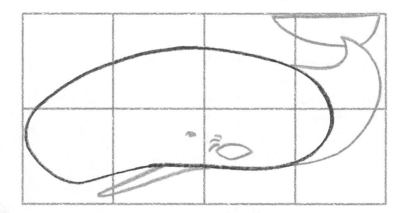

3.

Draw dorsal fins on the hook of the body. There are three fin lumps on this whale. Define the tail in the capped semi-circle.

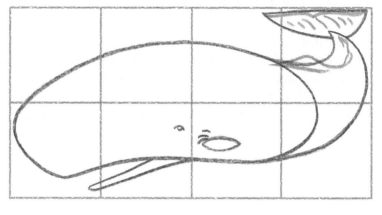

Artist Tip:

Adding a few different-sized bubbles here and there is a great way of making things look like they are under water. A wavy line with a few dots can make up the sand. Some seaweed and a couple of rocks can finish off the ocean floor. Keep background lines very simple. That way the object of the picture, the whale, stands out.

4.

The sperm whale is a whitish gray. In the water it can appear blue.

Surgeonfish

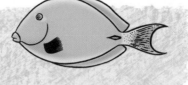

The Blue-Tailed Surgeonfish is a tropical fish that can be found along the eastern coast of Australia. They grow to be over one and a half feet (half a meter) long and have very small scales. They live in warm shallow water and coral reefs. Surgeonfish travel in schools and graze on algae, but will sometimes eat plankton.

1.

Draw a grid with four equal squares going across and two down.

Begin with a shape that looks like an egg on its side for the body shape.

2.

Draw in the mouth parts and add lines joining them back onto the body shape. Draw the squarish fin inside the body shape. Add the tail on the point of the egg-like body shape.

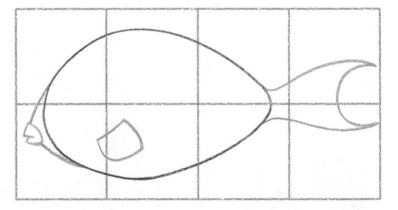

3.

Draw a curved line from the mouth up into the body shape. Draw in the eye.

Add long fins onto the outside of the body shape. These extend right through to the tail.

Draw in the diamond shape at the rear of the body. Finish with strokes and dots on the tail.

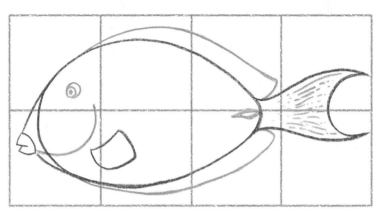

Artist Tip:

Merging means bringing two lines into one line smoothly. Notice how the lines for the front of the fish's face flow smoothly into the oval for the fish's body shape. Also, the beak and neck of the penguin merge smoothly onto both its head and body shape. You will notice that most of the shapes in this book have lines that merge into them.

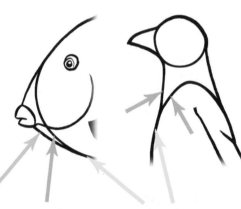

Face line Body shape Merged into one line

4.

Outline your artwork and erase the pencil lines. Fill in your surgeon fish with green, bright blue, and yellow.

The Walrus

Large and strong, the walrus powers its way through the sea. It dives deep to the ocean floor in search of clams, snails, worms, and crustaceans to eat. It surfaces and makes its way onto land where it sunbathes with friends. The walrus has two very long tusks, which it uses to drag itself along with on land and to defend itself against predators.

1.

Draw a grid with three equal squares going across and down.

Draw a circle right of the middle of the grid for the head. Draw the body shape that begins at the left side of the head circle. Check to make sure your shape is the same as this one.

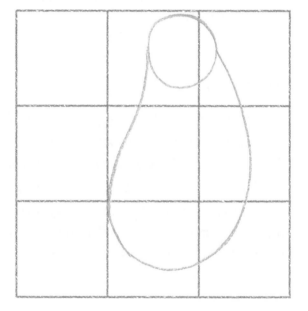

2.

Draw a circle slightly to the left and a little lower than the first head circle, but about the same size. This will be the snout.

Draw the lower body shape, making sure to merge it onto the original body shape.

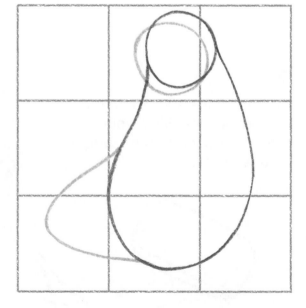

3.

Draw in the nose, which looks like a sideways "B," slightly to the left of the middle in the top of the snout circle.

Divide the cheeks in the snout circle with a line and draw in the long tusks. Draw in the front legs and fins. Add the back fin to finish this stage.

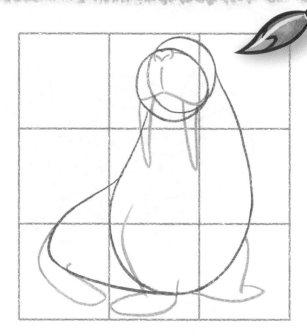

4.

Draw the eye and eyebrow on the top right of the head circle. Add whisker spots to the cheeks and a line to define the chin.

Separate the fins with some lines and add the crease on the back.

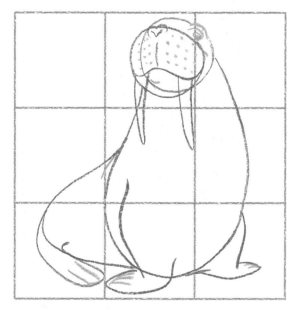

5.

Once you have outlined the picture and erased the pencil, put in a few selective whiskers coming from the whisker spots. Do not put too many in as it will darken the drawing too much.

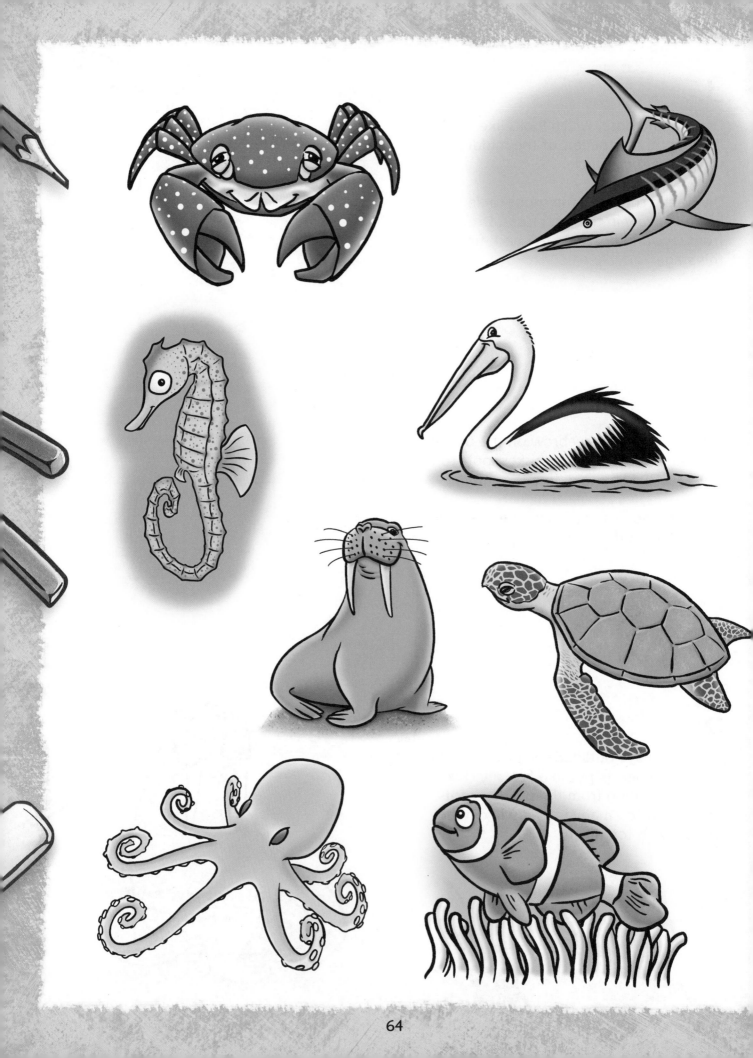

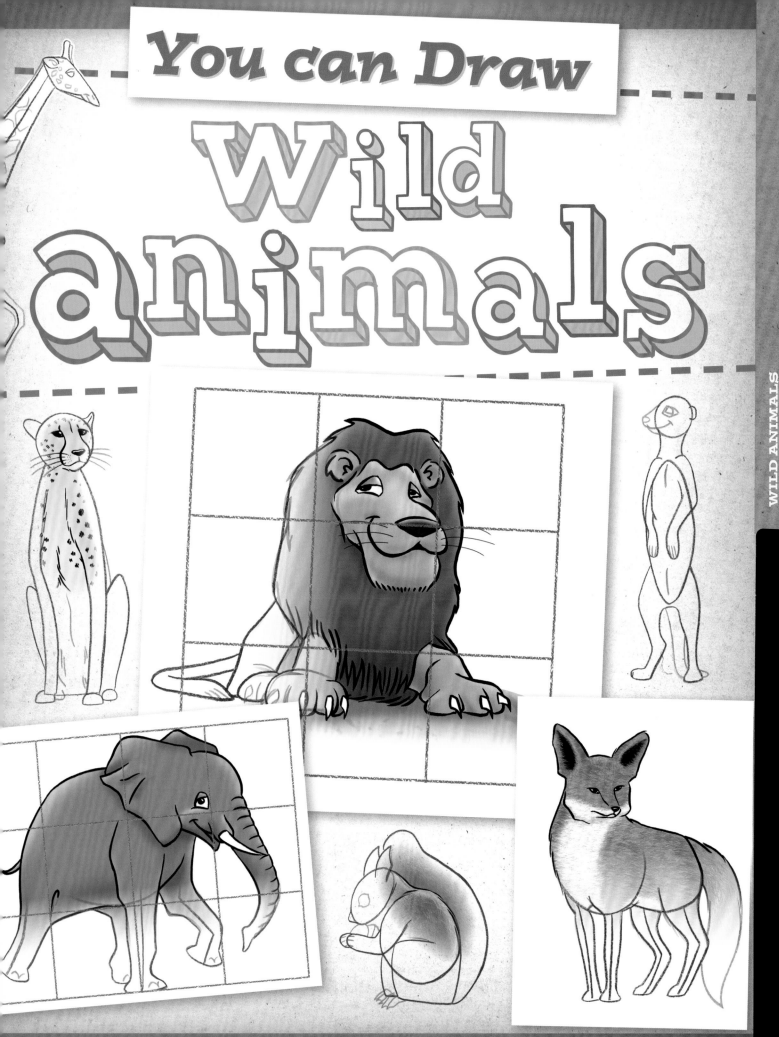

You can Draw
Wild animals

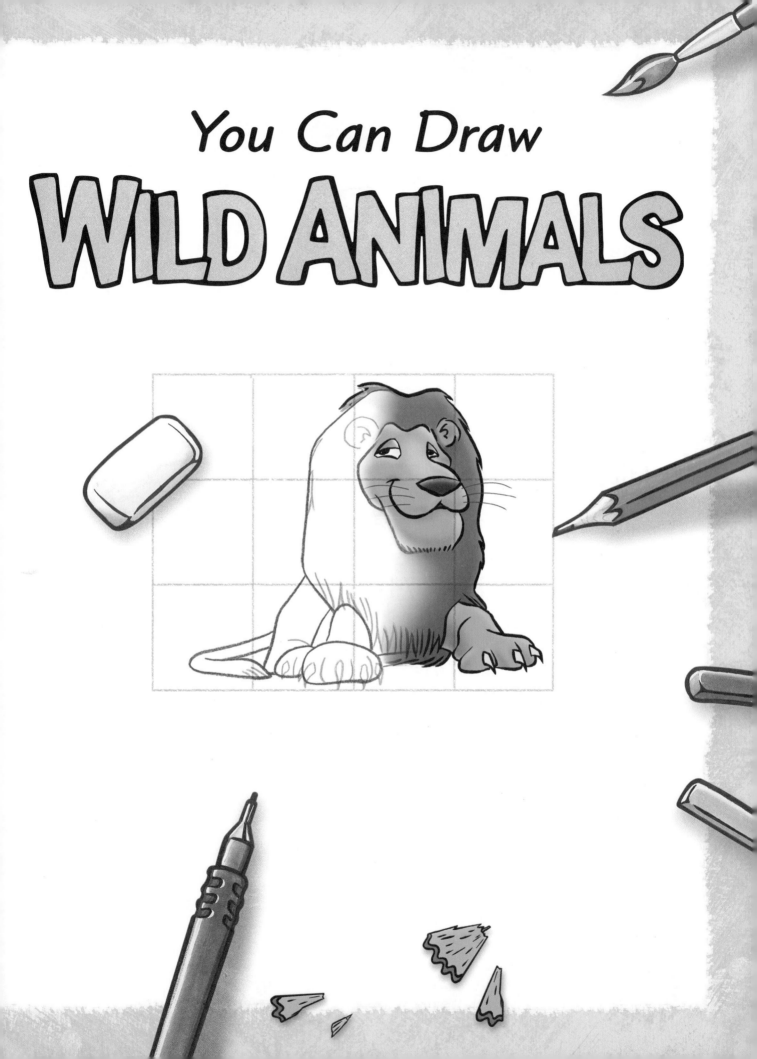

Contents

The Elephant

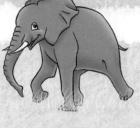

The elephant is the largest land mammal in the world. This huge animal can weigh more than four and a half tons and can spend up to 20 hours a day eating grass, leaves, and bark. Elephants live in groups called herds. An elephant's life span can be as long as 80 years.

1.

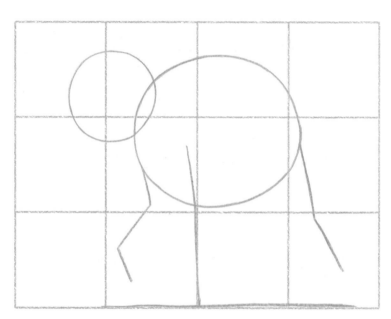

Draw a grid with four equal squares going across and three down.

Draw the oval for the body first. Next draw the circle for the head. Notice how the front wire-frame leg is at the end of the body shape. The middle wire-frame is nearly half way along the body shape. The last wire-frame leg is at the other end of the body shape.

Draw in a ground line and check everything is in the right position.

2.

Draw in the tusk near the bottom left of the head circle. Add on the legs based on the wire-frames. Notice how the middle leg extends right up into the body.

The back leg flows smoothly onto the body shape so there is no way to tell where it joins.

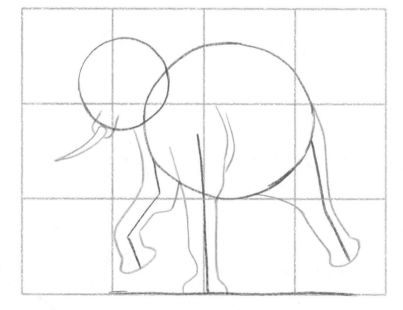

3.

The trunk flows off the head at the front in the same way the back leg flowed off the body shape in the previous stage.

The mouth starts under the tusk and extends outside the head circle. Above the mouth is the cheek and eye.

Add in the other back leg, which is situated behind the middle leg. Draw in the crease in the back leg and add on the tail.

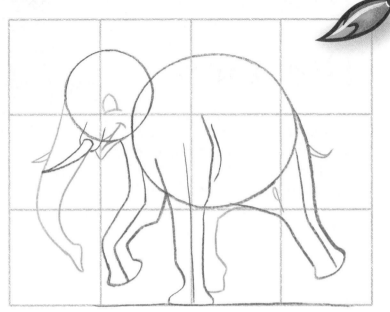

4.

Draw on the curved ridges of the trunk. Add the eyeball and the ears.

Imagine where the front of the elephant's foot is on each leg and add some toenails.

When you are ready to outline your artwork remember to only draw in the lines needed to make the picture. Check the final picture to see which ones you need.

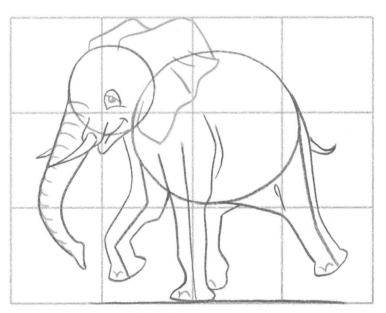

5.

Once you have erased the pencil lines, shade in your elephant and add some dry grass.

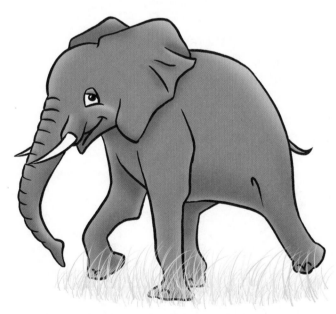

The Lion

Lions live and hunt in groups called prides. Great eyesight and a keen sense of smell helps the lion catch its prey. When chasing, they can reach speeds of up to 50 miles (80 kilometer) per hour. Resting is also important. A lion can sleep for up to 20 hours a day. A lion's roar can be heard nearly three miles (five kilometer) away. Only male lions have a mane.

1.

Draw a grid with four equal squares going across and three down.

Start by drawing a shape for the snout. Add a similar shape for the head behind it. Check to see if your drawing is correctly positioned on the grid.

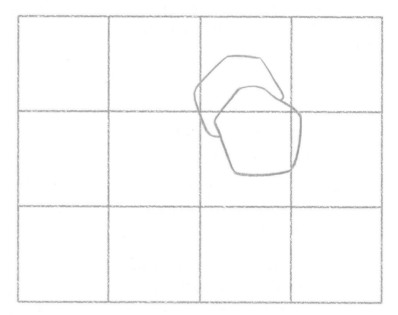

2.

Draw in another shape around the first two shapes. This will be the mane around the neck.

Add shapes for the feet and the legs coming out of the mane.

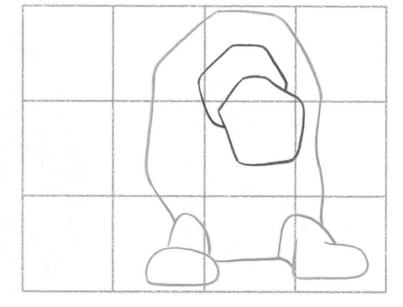

3.

Draw in the shapes for the back leg, foot, and tail.

Draw in the nose on the right side of the snout shape. Modify the mane that was drawn in the last stage.

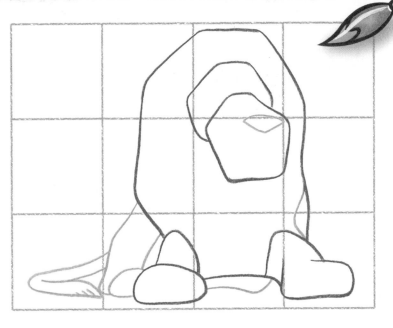

4.

Draw in some lines and points to make the mane look scruffy.

Put the ears on just outside of the head shape. Draw the eyes pushed up by the cheeks. Divide the mouth parts into a curved "W" and define the bottom jaw.

Finally, divide the foot into paws and add sharp nails.

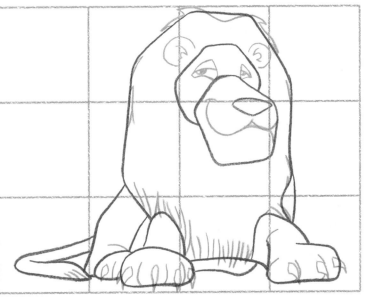

5.

Outline your lion with a felt-tip marker and erase the pencil lines. You are now ready to shade. Keep the body a tan shade of brown while making the mane a darker, more reddish brown.

Hippopotamus

The hippopotamus is a huge animal that can grow to be over twelve feet (four meters) long and weigh nearly two tons. Its head alone can weigh a ton. It eats up to 100 pounds (45 kilograms) of leaves per night and during the day retreats to the cool of the river where it can drink up to 65 gallons (250 liters) of water. Hippos are only found in Africa where they live in herds.

1.

Draw a grid with four equal squares going across and three down.

Draw in the head circle first. Add the body shape. Make sure the body shape is correct before going to the next stage.

2.

Draw in a wavy line for a water line. The water line in front of the hippo should be a little lower than the rest of the water line.

Note where the legs are in relation to the grid and draw them in. Because the legs are so short there is no need for wire-frames here.

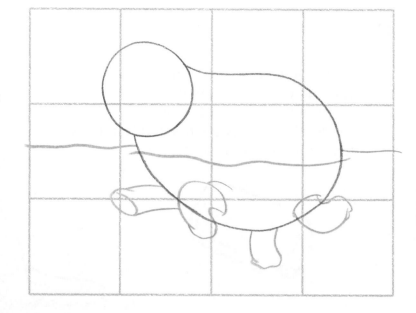

3.

Draw the mouth and define the eye on the head circle.

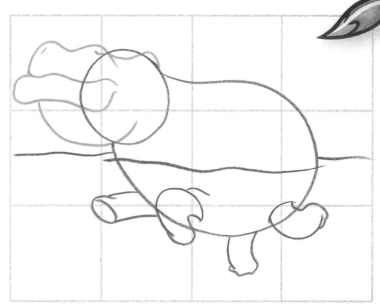

4.

Add on the eye and ear and the creases on the back of the neck, and you are ready to outline your hippo.

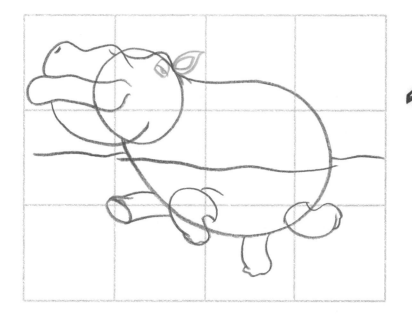

5.

Shade in your hippo and the water. Notice how the hippo is darker below the water line.

Rhinoceros

Rhinos are large animals found in both Africa and Asia. They can grow to be nearly six feet tall (two meters), twelve feet (four meters) long, and weigh almost two and a half tons. Being herbivores, they only eat grass and leaves and sometimes plants with sharp thistles. Rhinos have excellent hearing but cannot see things close to them very well.

1.

Draw a grid with four equal squares going across and three down.

Start with an oval for the head. This oval is on a slight angle. Draw in two larger and wider shapes behind the first oval. Notice these shapes are pointier than a normal oval. They are more like an egg on top.

Check that your shapes are correct and in the right places on the grid.

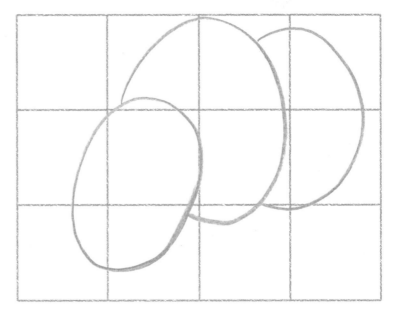

2.

Use the grid to position the horns on the head circle. Draw in the lip outside the head circle.

The eye is slightly below the middle of one of the grid squares. Draw a leaf shape for the ear in the top half of the grid square.

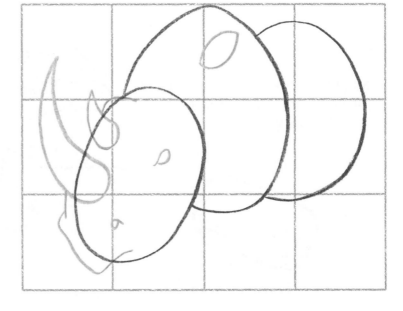

3.

Draw in the other ear opposite the first ear. Continue the head above the first head circle. Add some crease lines around the first ear and around the eye.

Draw in the legs and rounded shapes for the feet.

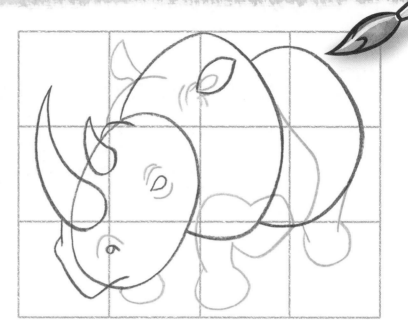

4.

Draw creases in the shoulder above the front leg. Draw a curved line between the front and back leg to define the stomach.

Break the feet up into toes. Notice how the back toes are smaller than the front ones.

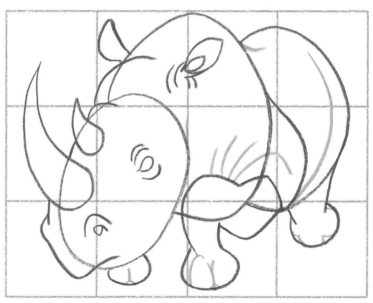

5.

Outline your rhino and erase the pencil lines. Rhinos can be different shades, from white to gray to brown. You could put a shadow half an inch (one centimeter) below the rhino's feet to show it is in the air running.

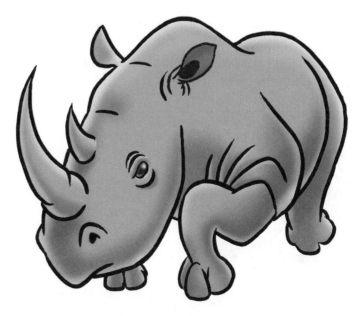

The Cheetah

Cheetahs are long, thin cats and are well designed for speed. In a chase, they reach speeds in excess of 60 miles (100 kilometer) per hour. This makes them the fastest animal in the world. Cheetahs cannot roar, but make a sound called a "chirrup."

1.

Draw a grid with two equal squares going across and four down.

Draw in the basic shapes in the correct position on the grid. Check to make sure your shapes look the same as the shapes on our grid.

2.

Add another circle in the lower left corner of the original circle. This is for the snout. Draw the ears on the head circle.

Add shapes for the back legs on either side of the long body shape. Draw the two long lines inside the body shape. These will make up the front legs. Finally, add in the shapes for the feet.

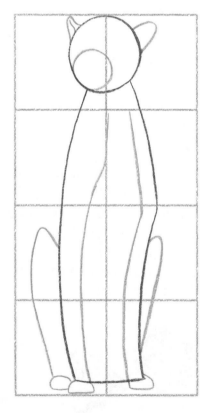

76

3.

Put the nose on the small circle drawn in the second stage. Position it just left of the middle of the bottom circle. Now break up the circle by drawing the curved "W" shape that makes up the cheeks and bottom jaw. Draw the whiskers coming out from each side of the cheeks.

Draw in the eyes, taking notice where they are positioned on the head circle. They are over half way up the circle and on the left hand side of it.

Draw in the line for the cheetah's back next to the leg on the left and some lines for the chest half way down the cheetah. Add some lines to show fur. Finish with the shape for the back foot on the right.

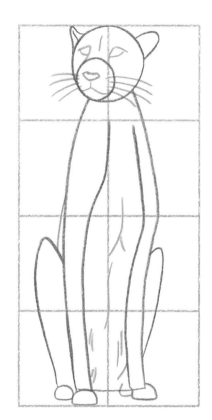

4.

Add spots to the legs, back, and head. Notice how the spots fade out by getting smaller around the face and eventually stop.

Be careful not to put spots too far into the chest or on the snout. Shade in your cheetah using yellow for the base and orange for the back, legs, and head. Leave the snout and the chest lighter than the rest of the animal.

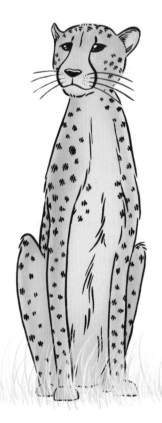

The Leopard

Leopards are very strong and fast members of the cat family. They can drag freshly caught animals that are much heavier than themselves up a tree to keep it away from lions and hyenas. They are amazing jumpers, able to leap 18 feet (six meters) forward in a single bound and ten feet straight (three meters) up. Each leopard has its own unique spot pattern.

1.

Draw a grid with three equal squares going across and three down.

First, draw in the head in the top left of the grid. Draw in the tall rectangle on its side under the head circle. Draw in the last shape on the right side to complete this stage.

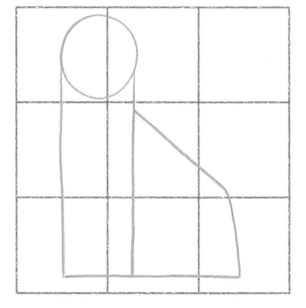

2.

Draw a small circle on the bottom of the head circle just going outside of the head circle.

Draw in the legs around and inside the long rectangle. Draw in the underside of the belly line and add the shapes for the back leg and the foot.

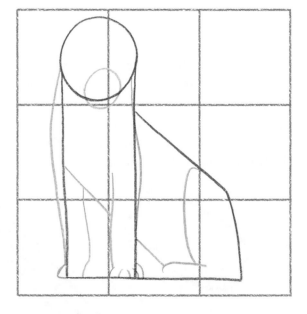

3.

Add the ears to the outside of the head circle. Draw in the facial features, being careful to put them in the correct place on the circles.

Draw in a line to divide the chest. Add the tail and back foot to finish.

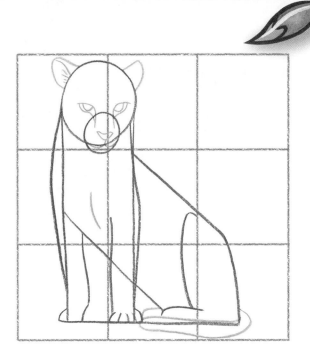

Artist Tip:

The leopard's mouth, chest, and stomach are all white. Notice though there is no edge to where the white starts and the yellow coat finishes. It is a gradual fade. When shading with pencil, push harder at the edge of the picture and gradually lighten pressure as you move toward the middle of the drawing. You may need to do this a number of times to build up the coat part.

Dark Light Dark

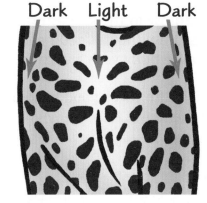

4.

Add spots to the head and chest, making them smaller as they fade out. The spots on the back have holes in them where the coat is slightly darker than the rest of the yellow coat.

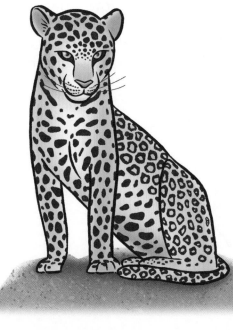

Giraffe

At 15 feet (five meters) tall, the giraffe is the tallest animal in the world. It eats leaves and can consume 130 pounds (60 kilograms) of leaves in one day. The giraffe's heart is as big as a basketball and, if challenged, it can kill a lion using its bony head.

1.

Draw a grid with three equal squares going across and four down.

First, draw in the shape for the body on the grid. Draw the pointed head shape and connect it to the body with a wire-frame.

Add in the curved and kinked wire-frames for the legs. Lastly, draw in a ground line.

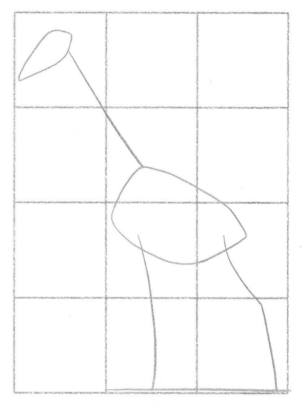

2.

Draw in the horn on the head and the facial features. Add the neck, being sure to make it slightly wider as it goes down toward the body.

Draw in the legs around the wire-frame guides and add the new wire-frames for the legs behind. Add on the tail.

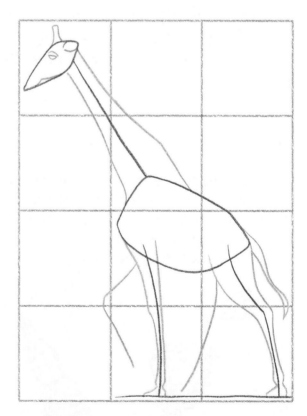

3.

Add the other horn on the head, and the far legs. Draw the mane on the back of the neck. Giraffes' manes are quite short so don't make it too thick.

Finally, add in the shapes for the pattern on the coat. Notice how they get smaller and fade out on the face and legs.

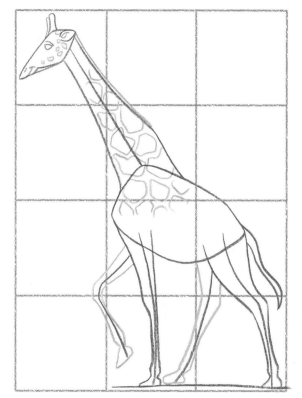

4.

Add spots all over the legs, back, and head. Be careful not to put spots too far into the chest or on the snout. Fill in your picture.

The Meerkat

Found in South Africa, the meerkat is a social animal. They love to play while one keeps watch for predators. During the day meerkats hunt for food. They eat worms, lizards, insects, and fruit. At night the meerkat sleeps in a burrow.

1.

Draw a grid with two equal squares going across and four down.

Draw in the basic shapes for the body and head in the correct position on the grid. Check to make sure your shapes look the same as the shapes on our grid.

2.

Draw the little ear on the head circle. Draw the neck and arms with rounded shapes for the paws.

Complete this stage by drawing in the legs and feet. Notice how one leg looks almost straight but the other one is bent. The leg that is straight is facing toward us, while the other one is turned to the side.

3.

Add the snout onto the head circle with the nose, chin, and eye. Divide the chest and stomach with two vertical lines. Separate the rounded paws into fingers. Draw in the tail and you are ready to outline.

4.

Meerkats range from being light yellow to dark orange. They are grayish white on their belly. They also have a dark patch around their eye and on the end of their tails.

The Fox

The Red Fox is the biggest in the fox family. They are slightly bigger than a cat and have a big, bushy tail. Foxes live around the edges of forests in England and hunt alone at night. They eat rabbits, mice, birds, and sometimes worms and beetles. The fox is at the top of its food chain and has no predators. Foxes are often thought of as being very clever.

1.

Draw a square grid with three equal squares going across and down.

Start with a circle near the top left of the grid. Draw another slightly crooked oval shape under the circle. Check your shape with this shape to make sure they look the same.

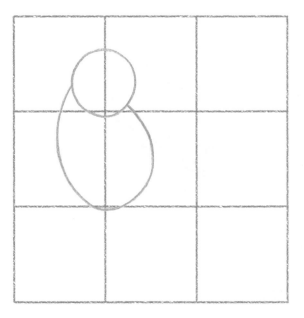

2.

Add on the ears to the outside of the first shape.

Draw another shape to the right of the crooked oval to form the back of the animal. Draw in the wire-frame lines for the legs, paying close attention to putting them in the right position.

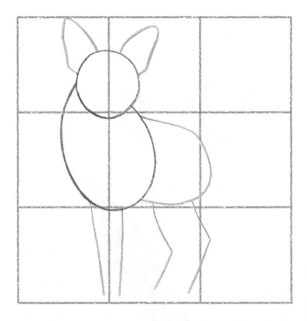

84

3.

Draw the shape of the legs around the wire-frames, using the wire-frames as a guide to keep them straight.

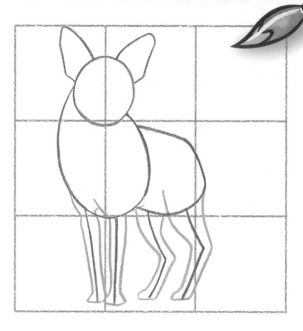

4.

Add in the cheek fur on the outside of the original circle. Then draw in the facial features on the bottom right of the circle. Add the bushy tail.

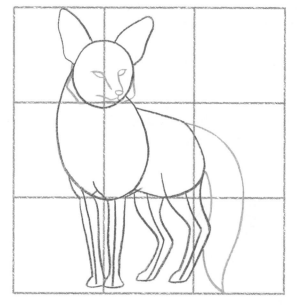

5.

Outline only those shapes you need to make the fox, erase the guide lines and fill in the fox to your heart's content.

Red Squirrel

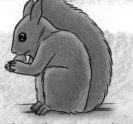

The Red Squirrel lives in trees. It can be found in the United States, Canada, and England. They are excellent climbers and can leap from branch to branch around the forest canopy. Squirrels are wary creatures. Great eyesight, sense of smell, and hearing all help to protect the squirrel from predators. A squirrel can fall from great heights out of a tree and live.

1.

Draw a grid with three equal squares going across and down.

Start by drawing in a circle for the body shape a little lower than the middle of the grid.

Draw in the head shape, which looks like an egg facing toward the ground on an angle.

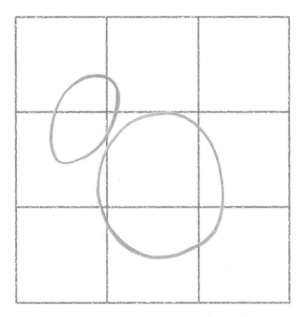

2.

Connect the head shape to the body shape with a curved line.

Draw on the arms. Notice how the arms flow off the edge of the circle at the top.

The squarish shape for the back legs also flows off the body at the back. Check your drawing is correct and move on to the next stage.

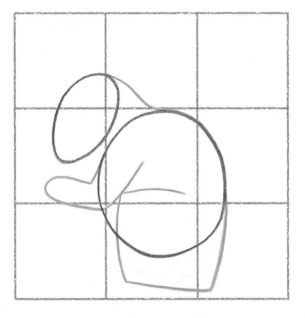

3.

Here we have drawn in the ears. They are curved to a point at the top. Draw on a little shape for the nose and add the other paw beside the first arm.

Draw in the other leg at the front. Draw in the long, thick tail that curves around the body and extends above the head and ears.

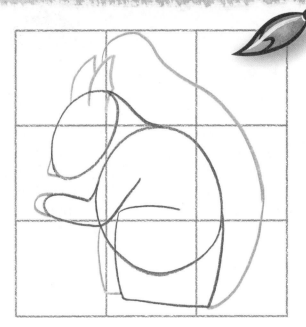

4.

Draw in an oval shape for the nut in its paws. Draw in a curved line that goes from the top of the nut to the body circle for its neck. Add in the other arm below the neck.

Draw the claws on the feet at the base of the square shapes for the legs.

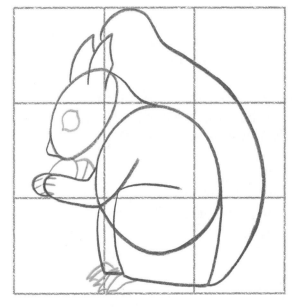

5.

Outline your squirrel and erase the pencil lines. Make it red while using brown for the shaded areas.

Weasel

Weasels can be found in the forests of the United States, Canada, and England. The weasel is best known for its ability to get through very small holes and crevices. They can also climb trees very easily. They will hunt rabbits, mice, snakes, moles and even eat insects. Preferring to hunt at night, the weasel will search for the tunnels made by these animals for its next meal.

1.

Draw a grid with four equal squares going across and two down.

Begin with a shape that looks like a hot dog for the body. Check it is in the correct position on your grid.

Draw a shape like an egg pointing forward in the top left corner of the grid.

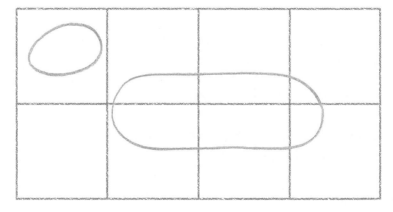

2.

Extend a point on the end of the head circle and curve it back under the chin. Add an eye in the head circle.

Draw a flowing line from the bottom of the head circle to the body shape. Do the same for the top.

Add a long, curved tail on to the hot dog shape.

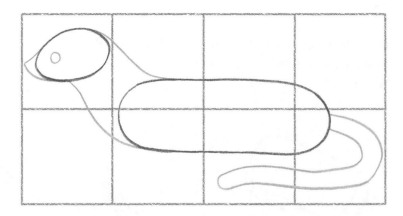

3.

Draw in some ears on the head shape. One is poking out the top and the other one is crossing over the head shape into the neck.

Draw in a few whiskers and a small line for the nose. Draw a line from the chin to the hot dog shape.

Add the front leg and a little shape for the back leg.

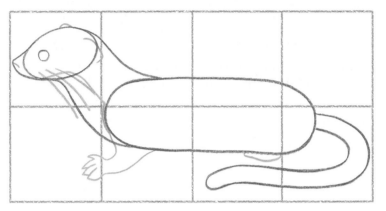

Artist Tip:

Making something look furry only takes a few carefully positioned pen strokes. The pen strokes come off the outline only slightly and a new line is begun underneath. Drawing too many strokes for hair darkens and unbalances the picture.

Stroke end comes off shape

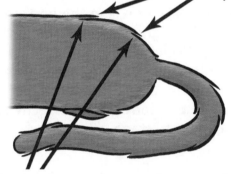

New stroke begins under previous stroke

4.

Make your weasel a reddish brown, leaving the chest white. Make the eye black, leaving a white highlight at the top of it.

Platypus

Platypus are only found on the east coast of Australia. They are about half the size of a house cat. They have a bill like a duck and a tail like a beaver. They use their bill to forage for food along the bottoms of rivers. They eat fish, fish eggs, frogs, and tadpoles. A platypus is able to hold its breath for ten minutes under water. At night they sleep in burrows in the river bank.

1.

Draw a grid with four equal squares going across and two down.

Begin with a circle in the bottom left of the grid. Add a shape for the body. Notice how the body shape is slightly rounder on top than on its underside. Check that you have drawn the body shape correctly and move on to stage two.

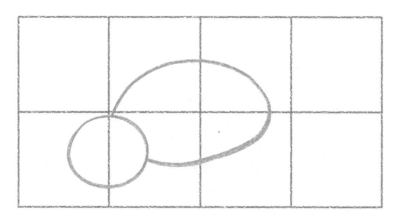

2.

Here we add the bill. It is very wide and fairly flat.

Add another shape on to the body shape at the rear.

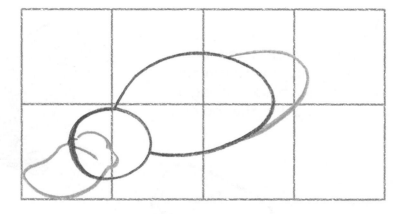

3.

Draw on the arms and legs. When drawing the tail, notice how it is quite straight and broad.

Make sure everything is in the correct position and move on to the next stage.

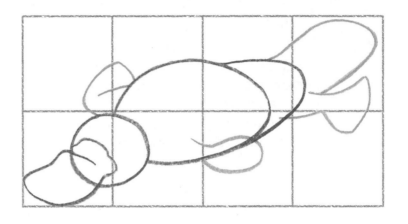

4.

Here we can finish with the detail. Put a couple of short lines on the end of the bill for the nostrils. Draw the eyes touching the bill.

Connect the head circle to the body circle. Break up the shapes on the end of the arms and legs into claws.

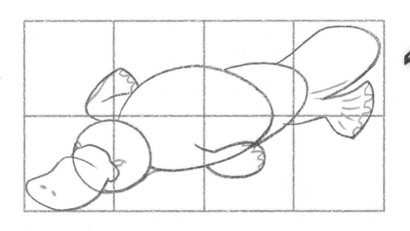

5.

Outline your platypus with a felt-tip marker and shade it. The platypus here is swimming, so you may like to put some water around it.

Kangaroo

Kangaroos live in Australia. They have strong, muscular legs and a thick, heavy tail. A kangaroo can only move its back legs together and uses its tail as a third leg when moving slowly. Kangaroos have good eyesight and excellent hearing.

1.

Draw a grid with three equal squares going across and four down.

First, draw in the body shape on your grid. Draw the head next and connect it to the body shape with a wire-frame. Check to see whether your shapes are positioned correctly on your grid.

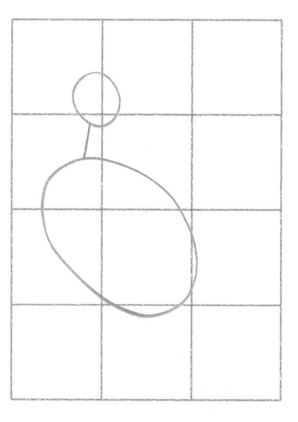

2.

Draw leaf-shaped ears on the head circle. Notice how the ear on the right is slightly smaller because it is further away.

Add the snout and mouth. Draw in the legs and the feet.

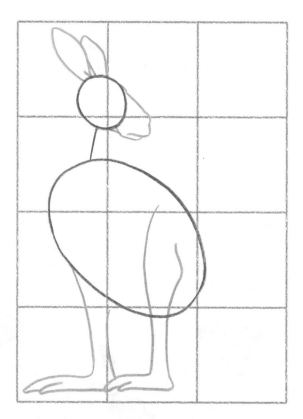

3.

The facial features are next with the eye, nostril, and dividing line for the cheeks.

Next, draw in the neck and arms. Draw in the underside and the tail to complete this stage.

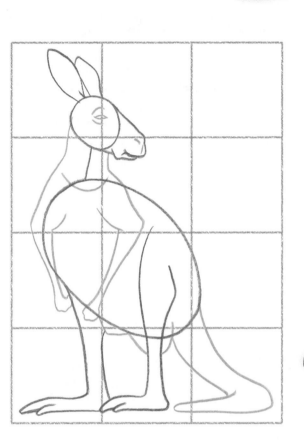

4.

This is an Eastern Gray Kangaroo, so we have made it a bluish gray.

Crocodile

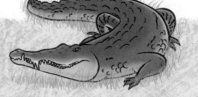

Crocodiles are large reptiles. They live on both land and water. On land they can move at speeds of 50 miles (80 kilometer) per hour in short bursts. Under the water they can hold their breath for five hours. They can also go months without eating. Crocodiles are cold-blooded, which means they have to lie in the sun to warm themselves up.

1.

Draw a grid with four equal squares going across and two down.

Start with a shape that looks like a stretched egg in the bottom left hand corner of the grid.

Draw in the "S" shaped line. This line is a guide that runs through about the middle of the animal. By having this guide, the body and tail can run in line with it.

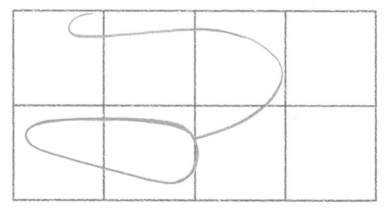

2.

Build the body shape along the line, bringing it to a point at the end of the line. Notice how the body widens and then tapers off to a point at the end of the tail.

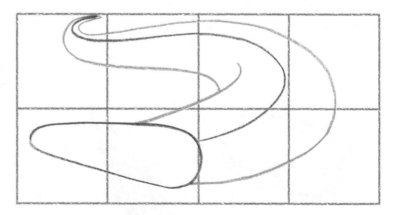

3.

Add the shapes for the legs, being careful to place them in the correct positions on the grid.

Draw in two wavy lines for the crocodile's mouth.

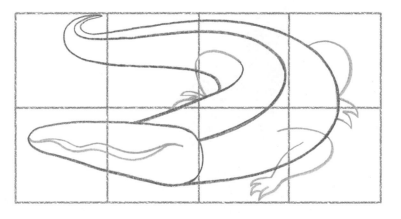

4.

Put in some large, spikey teeth and then add in the rest of the teeth with a simple zig-zag pattern.

Redefine the snout and add the eyes and edges above the eyes.

Draw in some scales running along the top of the back and then some on the side of the body.

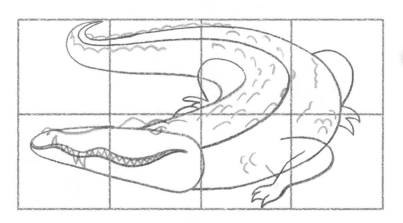

5.

Crocodiles are lighter on their belly and generally a darker green on top.

You may like to draw a river scene in the background. You could draw a set of eyes poking out of the river as if another crocodile is lurking nearby.

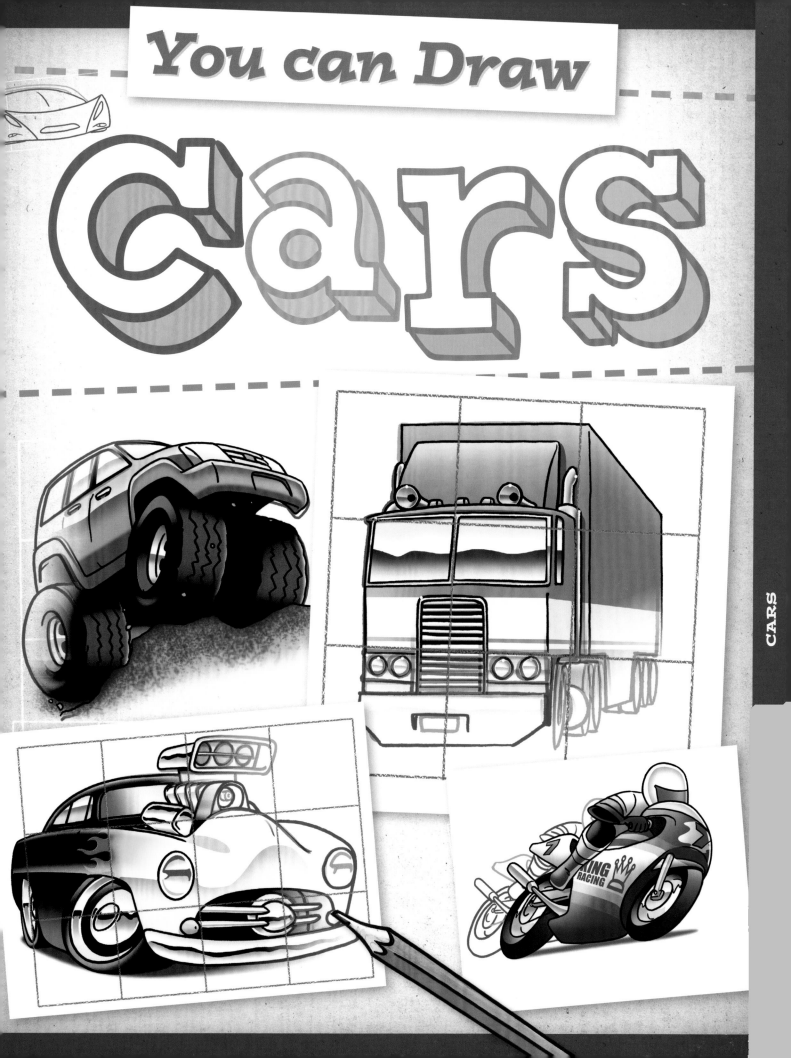

You can Draw

Cars

You Can Draw
CARS

Contents

Truck

With their loud deep horns, huge wheels and big engines, trucks are the biggest vehicles on our roads. They range in size from the lighter delivery trucks to the 18-wheel semi-trailers. Most trucks have a horn that you pull down, rather than press with your finger. Their main use is to transport goods. The largest truck in the world can carry around 400 tons!

1.

Begin by drawing a grid with three equal squares going across and down.

Start by drawing the squarish shapes in the correct position on the grid.

2.

Draw the truck's grill and light panels. Draw in the two windshield windows. Define the cabin and add the side window.

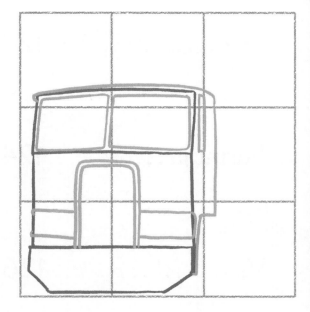

3.

Draw the lines for the grill. Add the headlights and place for the licence plate. Draw in the exhaust pipes, horns, lights, and the windbreak on the roof.

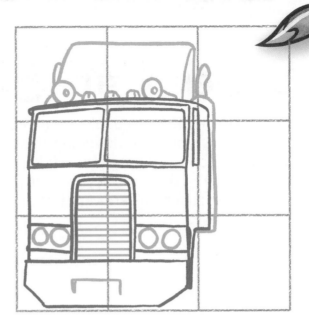

4.

Finish by drawing the trailer. Make sure your truck's wheels are tall and skinny.

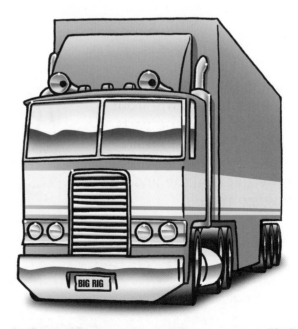

5.

Outline your drawing and erase the pencil lines. Fill in your drawing. The graphics on trucks have lots of different patterns. Maybe you could invent some of your own for the front and side of your truck.

BIG RIG

Super Car

Super cars are the cars people dream about owning. A lot of time is put into designing them so that they look really good and have powerful engines. They have an aerodynamic body so they can cut through the air, like a plane. Super cars are very fast and very, very expensive.

1.

Begin by drawing a grid with four equal squares going across and two down.

Draw in the long, curved shape highest on the grid. Draw in the bottom curve, taking notice of the kinks at the corners of the triangle. Put in the lines to make the two triangles.

2.

Draw in the angled lights and air intake at the front of the car. Draw the parts of the front tires that are visible. Draw in the wheels at the side and the line between them.

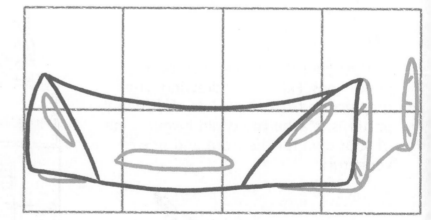

3.

Draw in the small air intakes in the front triangles. Add in the rounded shape for the windshield. Draw in the line for the side and add the side air intake.

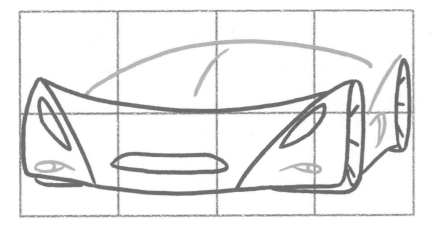

4.

Draw on the wing at the rear of the car to finish.

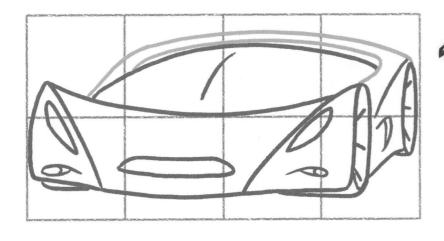

5.

Outline your super car and erase the pencil lines. Fill in your drawing. Red is often associated with speed and works well on this super car.

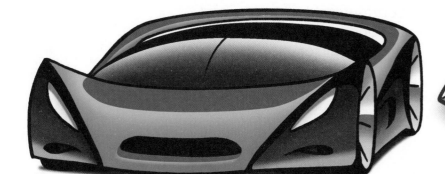

Sports Car

Sports cars are low, designed for quick response and good handling. They generally have two doors, two seats, and a roof that can be taken off. Sport cars are made for luxury, with all the latest car gizmos and gadgets. A sports car is really fun to drive on a nice sunny day.

1.

Begin by drawing a grid with four equal squares going across and three down.

Then draw the side of the car and a little of the front.

2.

Continue to draw the rest of the body and windshield. Add the side mirror.

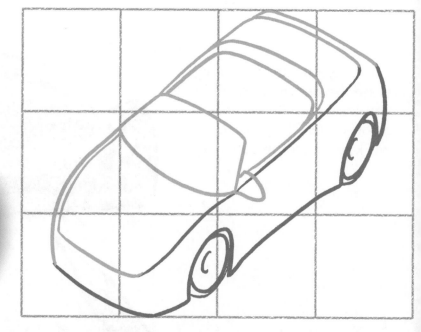

3.

Add the lights and front grill. Define the windshield and hood details. Add the far side mirror and seats. Draw in the door lines and handles. Finish by adding sporty shapes for the wheels.

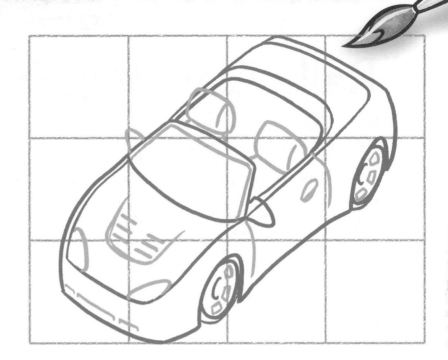

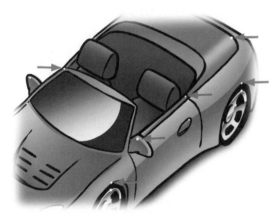

Artist Tip:

Light is reflected best on corners. Here we have added little light spots on some of the corners of the car to help it look shiny. To add these hightlights, fill in your whole car first and then look for little corners to highlight with a white dot. You can use white paint or even a correction pen for this. Little details like light-spot reflections can greatly enhance our drawings.

4.

Sports cars come in many different shades. This one is green, but you could make yours any shade you like.

Rally Car

Rally cars are off-road racers, driving at incredible speeds through mud, snow, and gravel. The navigator sits next to the driver, giving instructions on how to take the next turn. A lot of time is spent sideways and making split-second decisions about where to steer the car. Rally drivers have great reflexes.

1.

Begin by drawing a grid with four equal squares going across and three down.

Now, draw in the bumper and lights. Add the tight arch where the wheel will be.

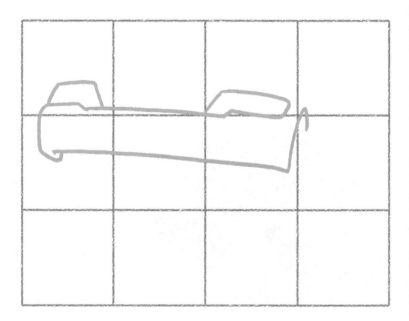

2.

Draw on the details on the bumper and grill. Add a curved line for the hood and the windshield above.

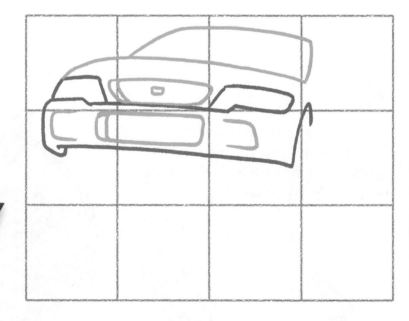

3.

Draw the fog lights on the bumper. Draw the front wheel and body side.

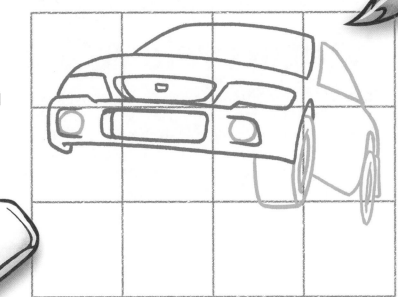

4.

Draw the roof line to the side window. Add lines for the doors and the door handles. Draw the top of the drivers' helmets. Add on the hood lines. Draw the shape for the rear wing. Draw in the underneath of the car and the rough ground below.

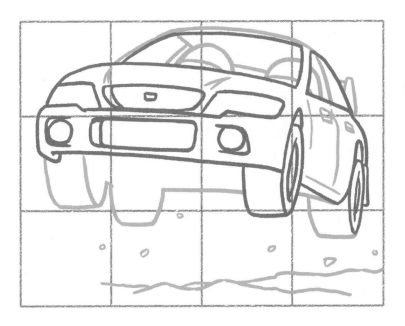

5.

Here I have made up a paint scheme and number for the rally car. You could make up your own pattern and put your own number on it.

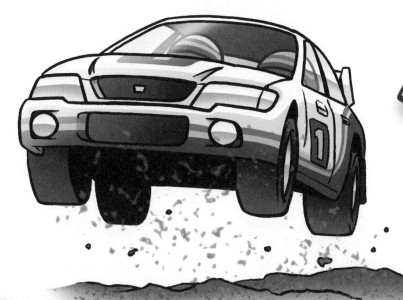

Motorcycle

There are a few different types of motorcycles, such as off-road and touring motorcycles. Not all of them have two wheels – some types come with three or four. Motorcycles are very zippy compared to cars. They don't use much fuel and are very easy to park, which makes them great for transport. Motorcycles are lots of fun!

1.

Begin by drawing a grid with four equal squares going across and three down.

First draw the body shape, being careful to construct the lines in their correct place on the grid. Add in the exhaust pipe.

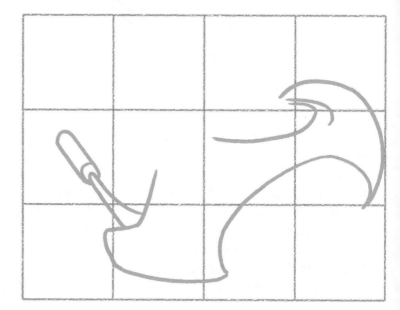

2.

Draw the leg first, followed by the arm and hand. Draw the line for the top of the gas tank. Draw on the cross-arm under the leg shape. Draw the piece of fork under the body.

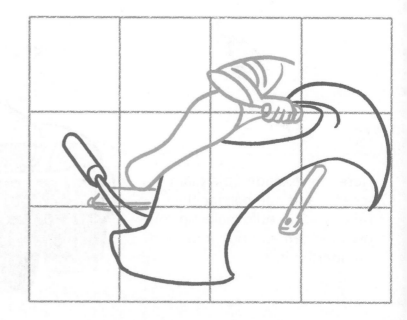

3.

Define the knee pad and boot with some curved lines on the leg. Draw in the rear and front wheels and details.

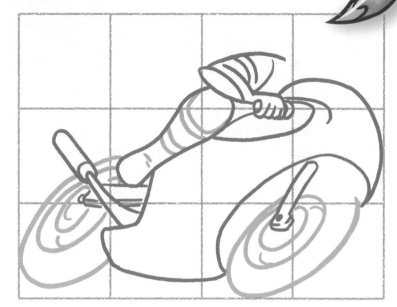

4.

Draw the helmet. Next, draw a line through the top of the body for the visor. Draw in the wheel cover on the front wheel. Add the rear and the seat of the bike. Finish by putting in the drive chain near the back wheel.

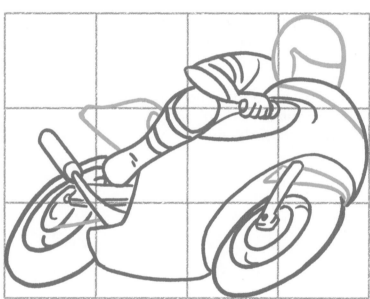

5.

Here we have designed a simple pattern and a made-up sponsor for our racing bike. See if you can come up with a pattern and sponsor for your motorcycle.

Model T

In the early 1900s, cars were just toys for really rich people. Henry Ford thought it would be a good idea if almost everyone could afford a car. So in 1908 he released the Model T, a car that was affordable for the average American. Henry Ford sold a lot of his cars and by 1914, he had made more cars than any other company.

1.

Begin by drawing a grid with four equal squares going across and three down.

Start with the roof and windows. Notice the curved line for the beginning of the hood.

2.

Draw in the hood lines and the light. Add the grill. Finish this stage with the wheel covers.

3.

Draw in the wheels. Add the far headlight, grill line and wheel cover. Draw in the spare tire on the rear and the door handle.

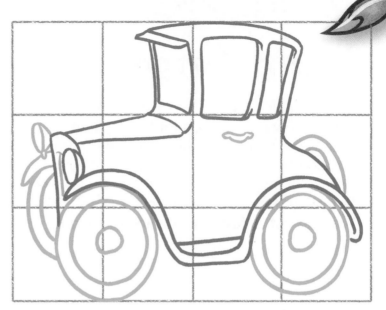

4.

Draw in the door lines and the spokes for the wheels.

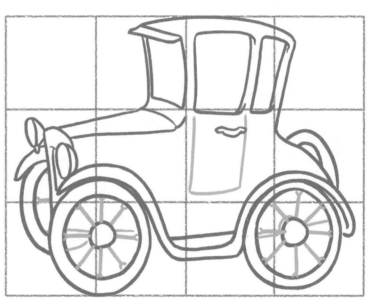

5.

We have made our Model T black. This was the only color that it came in! If we had made it completely black however, it would look like a black blob. By adding some white light reflections the car still looks black, but the different parts can be seen.

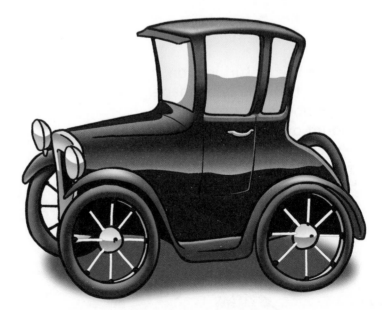

Land Speed Car

Land speed cars are the fastest cars in the world. They often look a lot like a plane because of their streamlined designs, which lets them cut through the air really quickly. Land speed cars can even have one or two jet engines to power their wheels. The record for the fastest land speed car is 765 miles (1227.985 kilometer) per hour! That's about as fast as the speed of sound!

1.

Begin by drawing a grid with four equal squares going across and three down.

Then draw the leaf shape for the cabin. Study the body shape to draw it accurately.

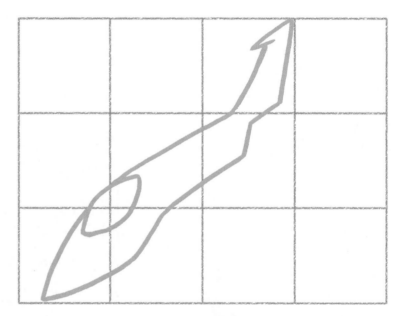

2.

Draw in the jet turbines on either side of the body shape. Notice how only a small amount of the far turbine can be seen. Draw in a small part of the rear wheel cover on this side.

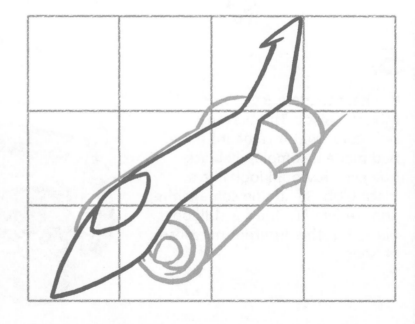

3.

Finish with the wheel covers.

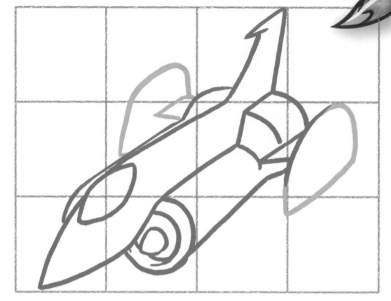

Artist Tip:

Things look smooth and shiny when a reflection is added. This is how it works:

1. This dotted line along the side represents a reflection off the ground. It could be reflecting a straight flat plane. If we were to reflect mountains, the reflection line would go up and down.

2. Here is a reflection of the distant sky, which appears lighter the further away you look. This is represented with a lighter shade. A contrast is created with the darker land shade, which looks great!

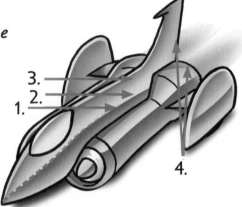

3. The lighter shade rises into a deeper blue, which represents the shade overhead. This same contrast reflection principle can be seen on many of the cars in this book. Try it, it really works!

4. The reflection of the flames can be seen on the back of the car, making it look more real.

4.

Outline your drawing and erase the pencil lines. Land speed cars do not have any specific paint scheme so you could make yours any shade you like.

Family Car

Family cars are made for safely carrying a family and their luggage from location to location. They are used to transport kids to school and bring the groceries home. These cars aren't built for speed, but a lot of time still goes into designing them to make them as safe as possible. Family cars are usually large and spacious.

1.

Begin by drawing a grid with three equal squares going across and down.

Draw the lights and bumper in the correct position on the grid. Keep the line going smoothly from the bottom of the bumper, around the wheel arch and along the body. Continue that line through the rear wheel arch, bumper, and tailgate.

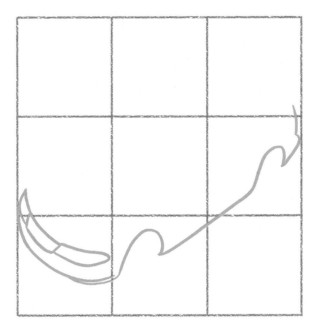

2.

Draw in the hood line going up over the windshield, roof and around to the tailgate. Add the windshield. Draw the side window, keeping it at the same angle as the line for the bottom of the car.

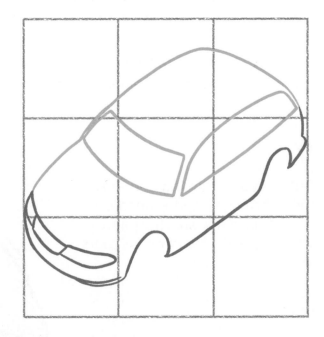

3.

Add the side mirrors. Draw a line from the windshield to the bumper. This will define the light and indicator. Add the side of the bumper and the lines on the hood and roof. Draw in the wheels to complete this stage.

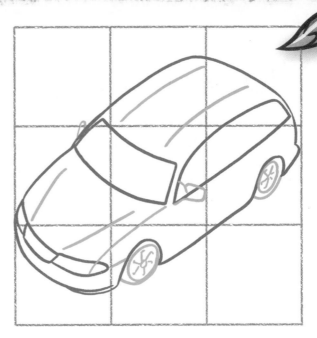

4.

Add the dividing lines on the windows, doors, and bumper. Finish with the door handles and the rear light.

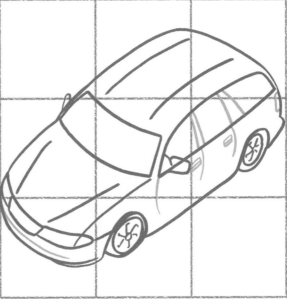

5.

Outline your drawing and erase the pencil lines. Family cars come in many different shades, so you could make your car any shade you like.

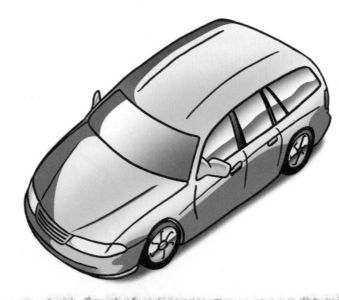

Dune buggy

Dune buggies are a cross between a car and a go-cart. They are made for fun! Dune buggies fly up and down sand dunes, and race along dirt roads. They have large tires that can go on all types of surfaces: gravel, dirt, sand, and even snow! A lot of people like to race their dune buggies. Another name for a dune buggy is a "sandrail."

1.

Begin by drawing a grid with three equal squares going across and down.

Next, draw the wheels. Notice they are on slightly different angles to each other.

2.

Add the inside details of the wheels. Draw in the side of the body. Add the lights and finish this stage with the bumper.

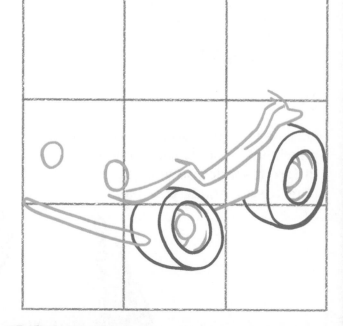

3.

Draw in the roll-bar at the rear. Add the side line, hood, and windshield. Draw in the light cases.

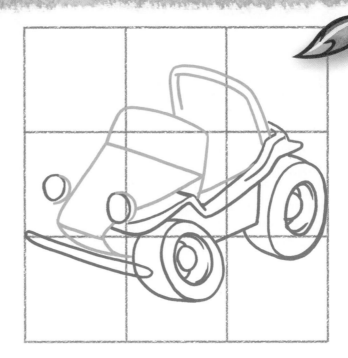

4.

Add the rear of the buggy between the roll-bars. Draw in the steering wheel and the seats. Add the lines on the inside of the lights. Draw the wheel cover on the far side and the wheel under it to finish.

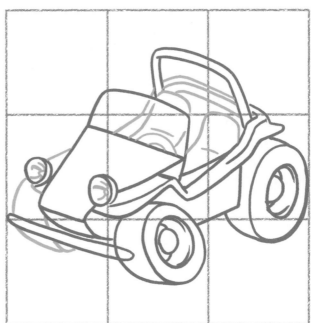

5.

Outline your drawing and erase the pencil lines. Since this is a fun car, we have used a bright design to make it more lively. You could draw someone driving it really fast across the sand.

Dodgem

Banging into your friends or unsuspecting strangers, then racing away to escape someone else crashing into you, that's the dodgem car experience! They are an attraction at most fairs, shows, and amusement parks. The cars are generally powered by electricity and most of the time they don't go as fast as you want them to. Dodgem cars often turn calm and safe drivers into crash-seeking maniacs!

1.

Begin by drawing a grid with four equal squares going across and three down.

Then start with drawing the eyes and brow in the correct position on the grid. Add the nose, mouth, and the line for the shoulder.

2.

Add the hair and arms with the hands at the end. Draw the steering wheel and then the surrounding lines for the car.

3.

Draw in the chin on the boy. Draw in the rest of the car.

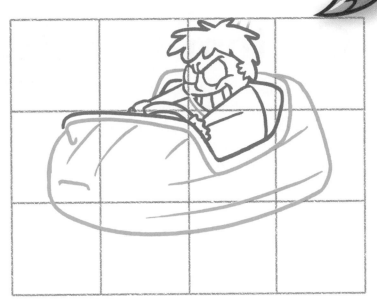

4.

Draw the eyes and the mouth on the car. Add the boy's eyes. Finish with the rubber surround on the bottom of the car.

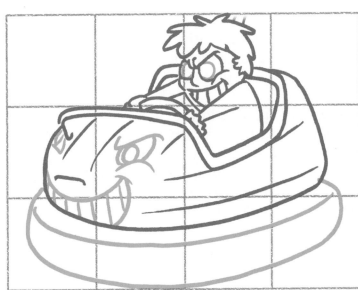

5.

Outline your drawing and erase the pencil lines. Fill in your dodgem or "bumper" car in your favorite shades.

Custom Car

A lot of time and money is spent on these cars to make them look, sound, feel, and run at peak performance. These cars are entered in shows and various competitions against other custom cars. Shiny paint jobs, big mag wheels and engines that poke out of the hood are typical features of a custom car. This type of car is made for its "wow" factor.

1.

Begin by drawing a grid with four equal squares going across and three down.

Now start drawing in the bumper. Add the indicator lights and the arc for the grill area. Draw in the wheel arch and front wheel. Draw in the rest of the body and the rear wheel.

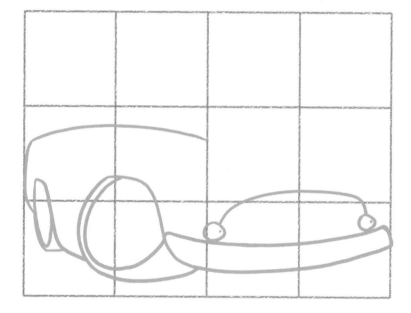

2.

Draw in the lights' circles. Draw the pieces for the grill and inside areas. Add the body shape above the grill and the engine parts. Add the detail on the inside of the wheels.

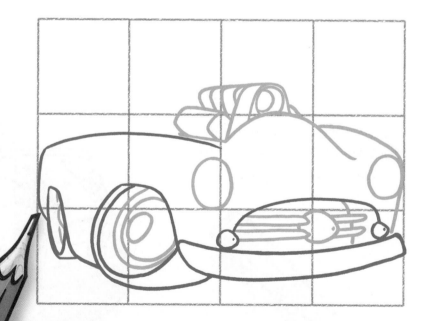

3.

Draw in the rest of the engine parts. Add the reflection lines in the lights and the circle in the grill. Draw the roof and windows. Finish with some short lines for the doors and get ready to outline.

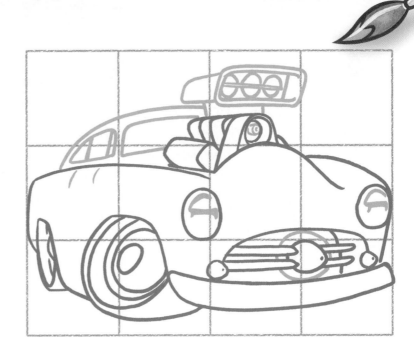

Artist Tip:

There are a few secrets to drawing great cartoony cars. They are:

1. *When drawing the side, have the distance between the wheels as close as possible, while still maintaining the normal wheel size.*

2. *Make the body really tall.*

3. *Make the side windows and roof line really short.*

These simple but effective principles will have you cartooning great cars in no time!

4.

Shade in your car. Study the metal parts closely. A light blue on top that fades into white, a black line through the middle, and a dark gray that fades make it look shiny.

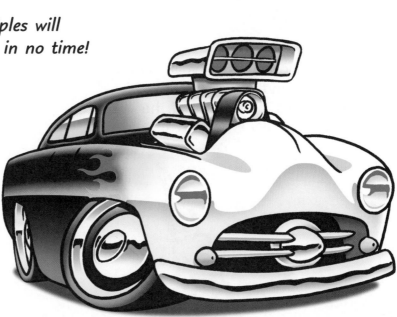

4x4

Real 4x4s are off-road cars. Jacked up high with added suspension and monster wheels, they force their way over huge obstacles and up really steep hills. "Four-wheel drive" means that if two wheels are bogged in mud, the other two can pull the car free. A stop at the car wash is often needed after the 4x4 has been through the mud all day.

1.

Begin by drawing a grid with three equal squares going across and down.

Next, draw the wheels. Notice how they are on different angles to each other. Draw in the rocky ground. Check to make sure you have placed everything correctly on your grid.

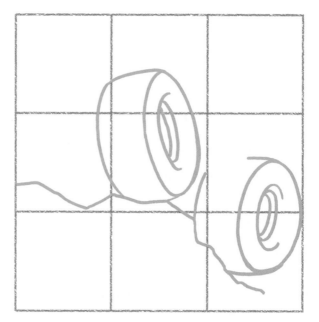

2.

Draw in the other front wheel. Draw the bumper and wheel arches. Add the line across the bottom of the truck and the rear wheel arch.

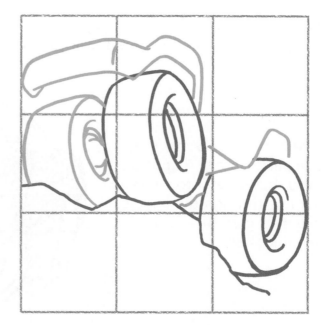

3.

Draw in the hood and cabin structure. Add the side window shape and the bottom door line going into the rear wheel arch cover.

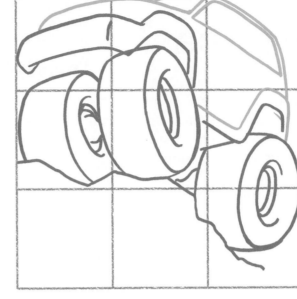

4.

Draw in the grill and lights. Add the license plate area. Divide the side window into individual windows and add door lines. Finish with the door handles.

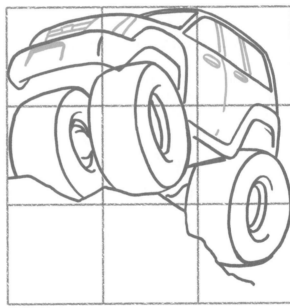

5.

Outline your drawing and erase the pencil lines. You could draw some more of the rocky road here or even put the car on top of a really high mountain.

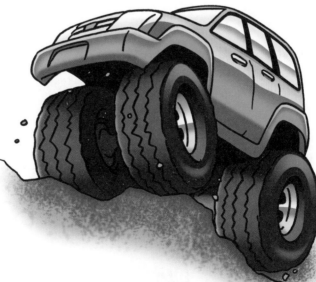

Formula 1

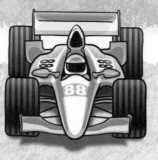

A Formula 1 car is very expensive. Loads of time is spent designing and maintaining these cars to make them as fast as possible. Millions of dollars are spent before a Formula 1 team wins an event. Formula 1 drivers have to know their car really well so they can speed around the track as fast as possible. A Formula 1 car can go over 185 miles (300 kilometers) per hour!

1.

Begin by drawing a grid with three equal squares going across and down.

Draw a rounded "V" for the nose cone. Add the wings either side.

2.

Draw the wheels either side and parts of the air intakes beside them. Add the curved shape for the cabin opening.

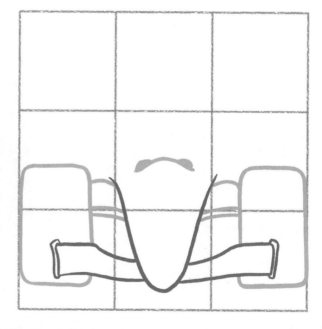

3.

Draw in the helmet and central air intake above the driver's head. Add the mirrors on either side. Draw the body shape to finish this stage.

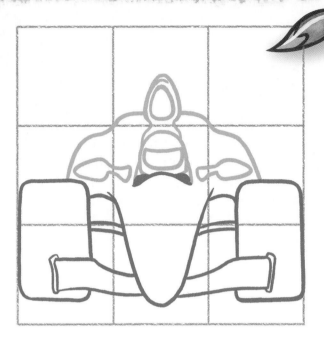

4.

Draw in the rear wing and wheel wings. Add the back wheels. Draw in the steering rod lines to the front wheels to finish.

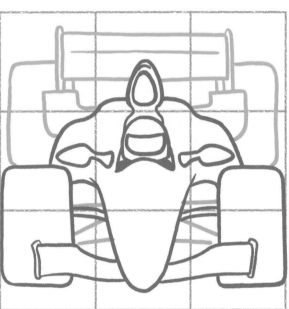

5.

Here we have used a simple paint scheme of orange and white. You could invent your own paint scheme and even your own team design, and also put it on the truck, rally car, and motorcycle pictures in this book.

Van

Vans make good family cars because they have room for all the people and their gear. Most vans have the engine underneath the driver and front passenger. Sometimes if people want to carry something really big, they fold down the back seats so they can fit the large object in.

1.

Begin by drawing a grid with four equal squares going across and three down.

Start by drawing the entire outside shape of the van. Be careful to note where each line intersects the grid lines.

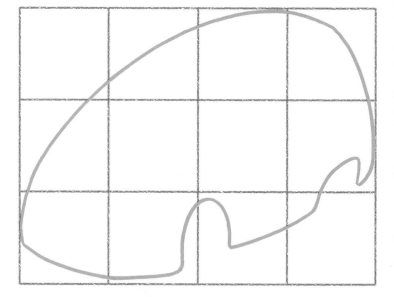

2.

Draw in the curved rectangle side door. Add the round shape for the windshield that comes to a point at the front. Draw in the dashboard and small air intakes at the bottom of the car's front.

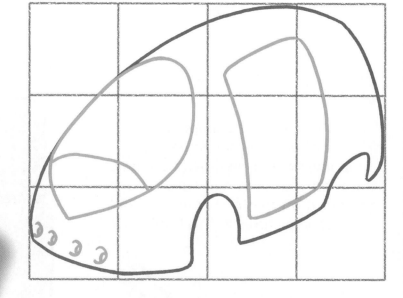

3.

Draw in the wheels and side mirrors. Add lines to define the front lights. Draw in the steering wheel.

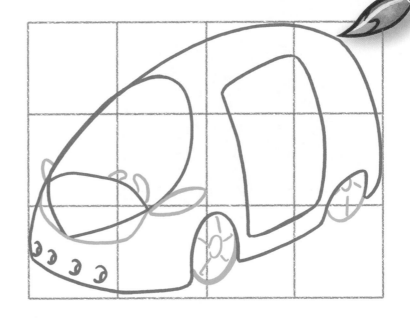

4.

Draw the two curving lines for the side window. The top one carries on over the windshield. Add the seats to finish.

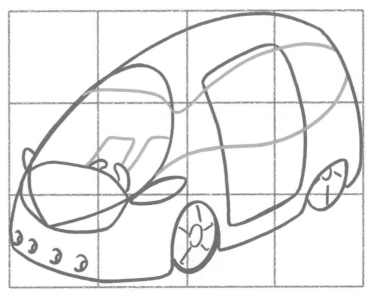

5.

Outline your drawing, erase the pencil lines and add your paint scheme. What futuristic town could your van be driving through?

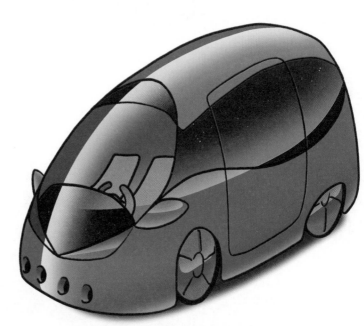

127

You can Draw
Cartoon Characters

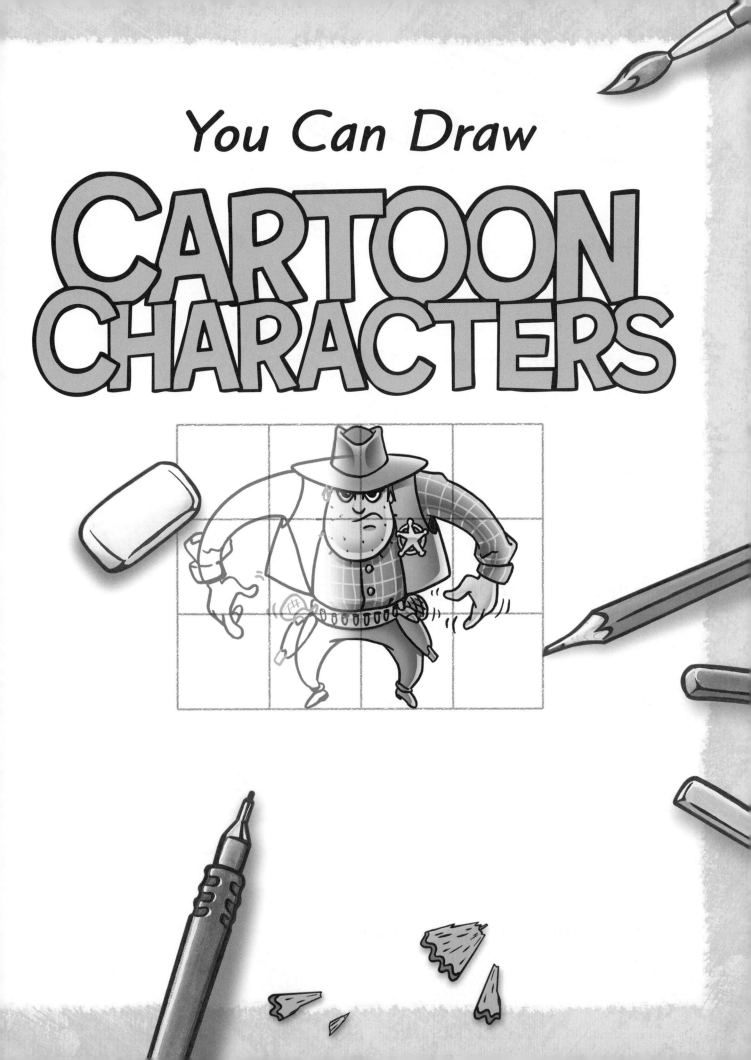

Contents

Thinker

Thinkers come up with ways to improve the way we live. They usually have a furrowed brow to show their deep thoughts and revolutionary ideas. Or, this guy might just be thinking about what to have for lunch.

1.

Begin by drawing a grid with two equal squares going across and four down.

Draw in the shape for the head with an ear. Notice the brow line is close to the top of the head. Add the upturned mouth. Draw in the jacket.

2.

Add some hair and his side-whiskers. Draw some creases in the brow. Add the nose and eyes. Draw in the hands and shirt cuff to complete this stage.

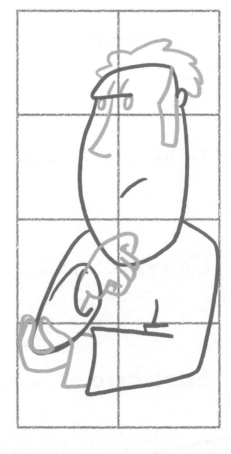

3.

Draw a line for the jacket cuff on the right hand. Add the glasses and a line for the inside of the ear to finish.

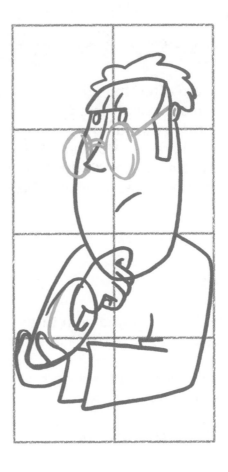

4.

Thinkers aren't known for their excitement, so they wear conservative outfits in whites, grays, and blacks.

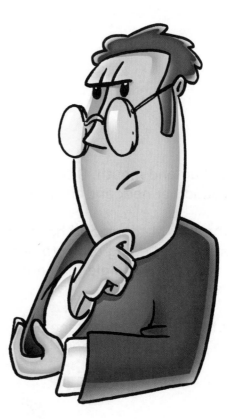

Sporty Grandma

Grannies are often thought to be fragile and content, relaxing in a rocking chair. Cartooning allows us the freedom to go outside the normal boundaries of reality and make characters do things they never would do. So what better way to do this than to have granny busting out on a fast break in a basketball game?

1.

Begin by drawing a grid with three equal squares going across and down.

Draw in the eyes and the eyebrows. Add the small nose and ear.

Draw in the cheeks and chin.

2.

Add the hair and mouth. Draw the frills around her neck and the arms.

Draw the frills at the end of her arms, and cone shapes going down to her hands. Notice how simple the hands are. Draw them in.

Complete the rest of this stage by drawing clothes and buttons.

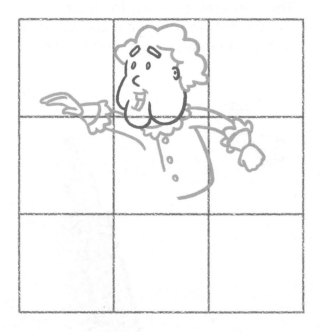

3.

Draw in the basketball and put a rounded cross on it.

Add the dress and the thin legs coming out from it. Check your drawing is correct and move on to the next stage.

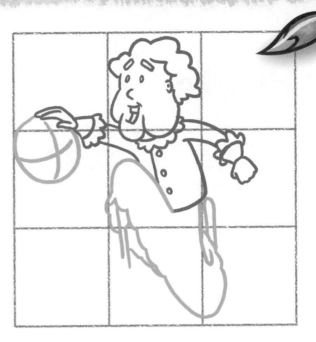

4.

Draw in the round lines on the ball. Add granny's glasses and her handbag. Draw the shoes and the dust-puff lines to show that she's moving quickly. Add the rounded movement lines to finish the stage.

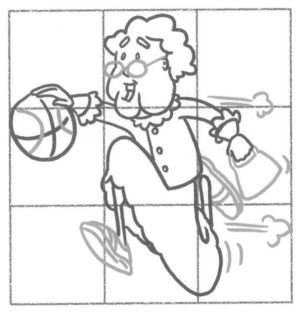

5.

Grannies usually have gray or white hair. They do not usually wear bright energetic clothes, but since this is a cartoon, you could make her any way you like.

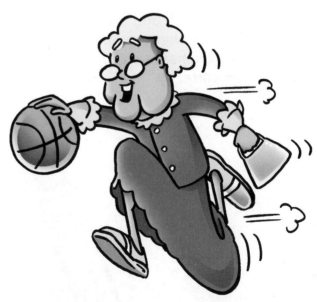

Pirate

Pirates are mean seafarers who are well known for their rough looks and attitudes. Wooden legs, hooks for hands, and eye patches are commonly associated with pirates.

1.

Begin by drawing a grid with three equal squares going across and down.

Draw in the eye and eyebrow followed by the nose. Draw in the other eye patch. Draw the ear and the large beard around to the eye patch.

2.

Draw in the mouth and the head scarf. Add the jacket top and the arms. Study the hands so you can draw them correctly.

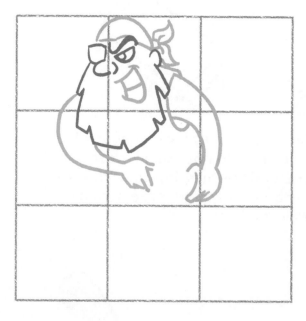

3.

Draw in the sword and sheath.

Add the rest of the jacket. Draw in the pants. Add the shape for the top of the boot.

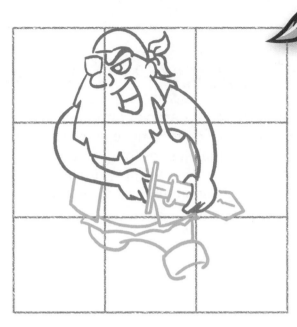

4.

Black out some teeth and add the wooden leg. Draw in the rest of the boot to finish this stage.

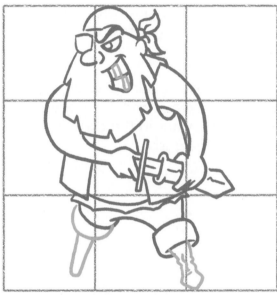

5.

You could have this pirate standing on the deck of his ship, ready for a sword fight.

Wacky Wombat

Wacky characters are very popular in animation. The character doesn't need to closely resemble the real animal, just as long as it has the animal's basic features. These simply drawn characters are commonly used in animated cartoons.

1.

Begin by drawing a grid with three equal squares going across and down.

Draw three shapes: a large circle, a small circle, and a roundish square. Check that they are in the correct position on the grid.

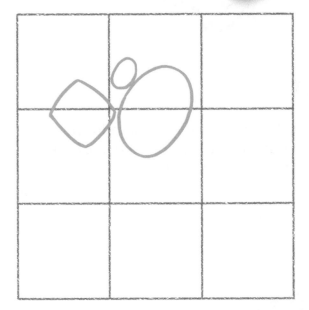

2.

Draw the eye pupils and a circle to define the highlights in the eyes. Add the head shape and ear, and continue the line under the nose and mouth.

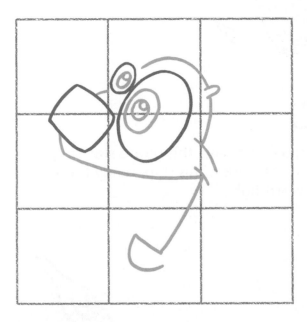

3.

Draw in the eyebrows far above the eyes and other ear. Draw the teeth and a line for the inner mouth. Add the body shape down to the little legs and pointed toes.

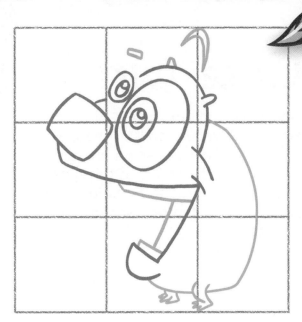

4.

Draw in a rectangle shape for the highlight on the nose. Add some droplets of water near the mouth. Draw the other arm and the noise maker in the wombat's hand.

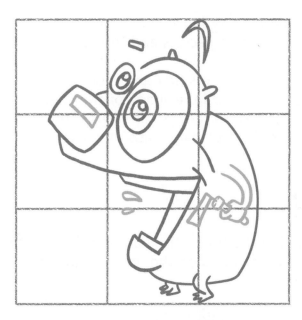

5.

Wombats are a darker brown than this. The realistic dark brown shade would make this wombat look heavy. Since we want to make the wombat look energetic, we've used a lighter shade of brown.

Cute Girl

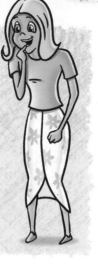

Innocence and simplicity is often associated with cuteness. A happy-go-lucky personality and a love of life go hand in hand with this type of character. Shrugged shoulders and slightly pointed-in feet accentuate this attitude.

1.

Begin by drawing a grid with two equal squares going across and four down.

Draw in the eyes first and then the small eyebrows. Add the shape of the cheeks and face. Draw in the hair line. Draw the neck and finish this stage with the little nose.

2.

Add in the top of the hair and the mouth. Draw the hand on the mouth and then the arm.

Draw the t-shirt and curved lines for the hips and legs.

3.

Draw in the arm and hand. Study the hand here to see how simple it is.

Add the rest of the skirt and the legs and feet.

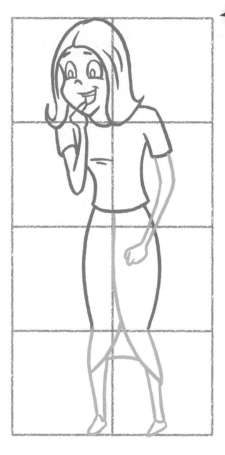

4.

When outlining your drawing, be careful to only ink the lines you need. Fill in to your heart's content. You may even want to put a different pattern on the skirt.

Mad Scientist

Working deep in his secret laboratory, this chemical cocktail-making madman is growing more insane with each devious thought. He is obsessed with his plan to take over the world. Wild hair and a torn lab coat are the result of past experiments gone wrong. Could this be the moment before this mad scientist's next unfortunate event?

1.

Begin by drawing a grid with three equal squares going across and down.

Start this stage by drawing the closed eye's eyebrow. Draw in the line for the closed eye and surrounding cheek and brow. Draw in the other eye and add the nose. Draw in the ear and mouth. Check that everything looks correct before moving on to the next stage.

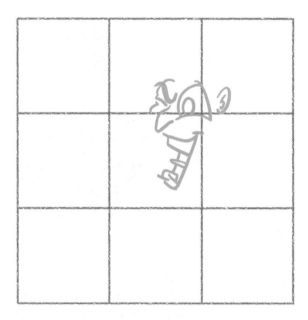

2.

Draw in the beard and underneath part of the open eye. Add the eyelid above the eye. Draw some crazy hair all around from his brow to his beard. Finish this stage by drawing in the curved arm.

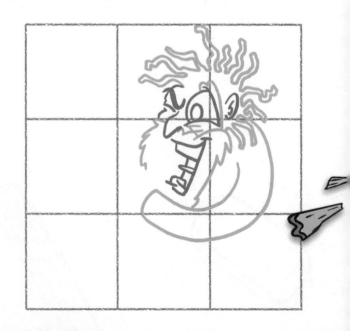

3.

Draw the hand and test tube. Add the collar of his lab coat and the flared-out bottom of it on either side. Draw in his legs and tiny feet.

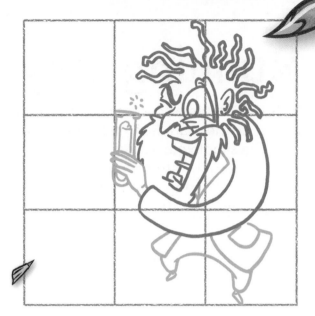

4.

Draw in the other test tube and hand. Draw in his torn coat arm right up to his brow. Add the steam to finish this stage.

5.

Could the green on this scientist be a reflection of the nuclear ooze glowing from the bench-top he is standing in front of? Or maybe some sort of radiation machine he has invented?

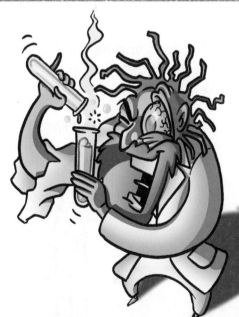

Running Boy

Kids love to play, which includes running as fast as they can. Running for the fun of it is a simple pleasure for these overly energetic life forms. This boy could be racing other kids, chasing a ball, or trying to escape from an imaginative monster in hot pursuit!

1.

Begin by drawing a grid with three equal squares going across and down.

Draw in the shape of the head with the hair. Add the sleeves of his shirt on a slight angle.

2.

Draw in his arms and hands. Notice there isn't much detail on his clenched fist.

Draw in his shorts, leg, and shoe.

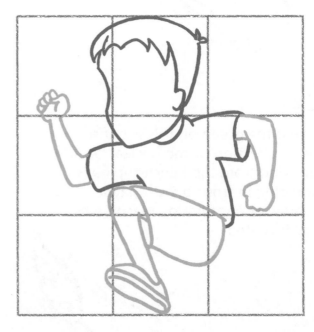

3.

Draw in his eyes, nose, and mouth. Put in a squiggly line for the inside of his ear. Add the other leg. Draw in the closer leg sock line to finish.

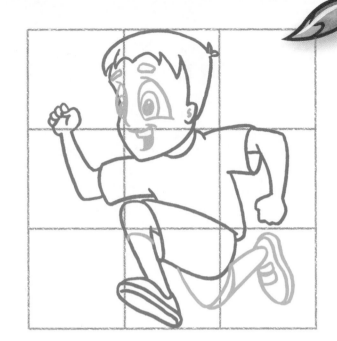

Artist Tip:

Cartoons have a lot of gaps around them. These gaps highlight action and movement. Notice this boy's legs are in an extreme pose: both are off the ground in full stride. The action is shown by the gap between the boy and the ground, where there is a shadow underneath. This enhances the feel of movement and speed. Have a look at some comic strips and you're sure to find this principle.

4.

Kids are often associated with bright blue, red, and yellow. These are bold, bright, and energetic. They also work very well together.

Sheriff

"This 'ere town ain't big enuff for the tew of us, so one of us 'as gotta go!" This sheriff is pumped in a ready stance to take on the outlaws in a quick-draw duel. He relies on his fast reflexes and sharp shooting to maintain justice in the West. Are you ready to draw?

1.

Begin by drawing a grid with four equal squares going across and three down.

Start with a rounded triangle for his hat. Draw the arms in a wide curving arc, starting close to the top of his hat brim. When drawing the arms, make them wider at the top and gradually thinner when they reach the wrist. Draw in his torso and the shape for his face.

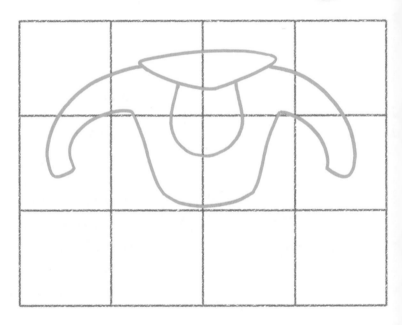

2.

Draw in the crown of his hat and his vest. Add the sleeves bunching up at his wrists. Draw in his belt and pants.

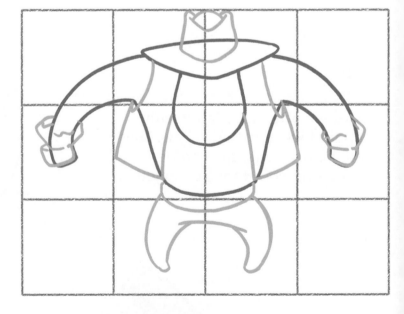

3.

Draw in two half circles under his hat for his eyes. Put in his nose and pushed-up lip. Draw two circles for his badge. Add his gun holsters at his side and the bullets around his belt. Put in his shirt buttons. Draw his ready hands and finish this stage with his feet.

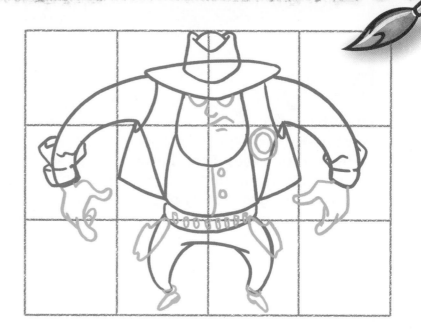

4.

Add the guns in his holsters, with some movement lines around them and his fingers. Draw in the star on his badge. Add some whiskers around his chin and some dots for whiskers on his face. Draw the pupils in his eyes to finish.

5.

Cowboys wear leather belts, jackets, and shoes. These are often tan (light brown) or black. They also often wear blue jeans. The "bad guys" in films often wear black.

Baby

Babies have very distinct features, which makes them great for cartooning. They have huge heads and large eyes. They are very plump and can often be seen crawling around wearing only a white diaper and sporting a giant safety pin. Their only accessory is a pacifier, which is most likely found on the ground beside their stroller.

1.

Begin by drawing a grid with three equal squares going across and down.

Draw in a three-quarter circle for the head. Add two shapes for the ears. Draw in the stretched oval shape for the chin.

2.

Draw in the big eyes and the eyebrows. Add the little nose and the inside of the ear lines.

Draw the shapes for the feet.

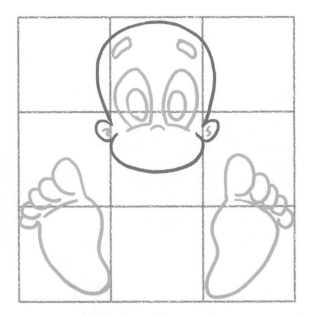

148

3.

Add the lines on the feet. Draw in the plump legs and the oval shape for the diaper. Draw two lines up from the diaper for the baby's chest.

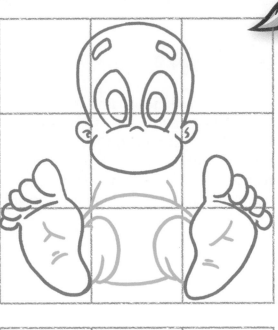

4.

Draw the shoulders and arms and the bits near the feet. These are the baby's hands.

Draw in the pacifier to the right of the face.

Add the safety pin and you're ready to ink!

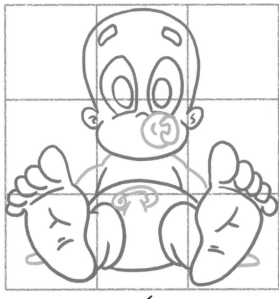

5.

Babies have blue eyes when they are born. They also wear white diapers. If you look closely, you will notice that the diaper is not perfectly white. By making it a very light gray or blue, it can still seem white, but more realistic.

Villain

Evilly inclined, these villains are devious figures. They devise ways to subdue mankind so they can control the world. Their ideas never seem to go as planned because of the hero, who always seems to be present just before the moment the villain will reach glory.

1.

Begin by drawing a grid with two equal squares going across and four down.

Start with the villain's eyes, eyebrows, and nose. Add the large rounded brow. Draw in the mouth and ear.

2.

Draw the beard and the top of the head. Add in the huge collar, pointing into a "V" at the chest. Draw the shoulders and the curved arm sleeves. Add thin wrists and a ball for the hands.

3.

Draw in some squiggly lines for the fingers. Finish off by adding the coat. Notice how it is draped along the floor.

4.

Villains usually wear fancy darker clothes. They rarely wear bright shades. This helps them seem more sinister.

Henchman

These goons are a villain's number-one recruits. They are generally big, strong, and unable to think for themselves, which makes them perfect to carry out the villain's every command. Henchmen are also bodyguards for the villain and are always dressed in black suits.

1.

Begin by drawing a grid with two equal squares going across and four down.

Draw in the face, making the chin big and the rest of the head small. Draw in little ears and a thick neck.

2.

Draw in his collar and shoulders. Add his left arm and then continue with his chest, stomach, and other arm.

3.

Draw in his hand. Draw the pants getting smaller as they go down and add tiny feet.

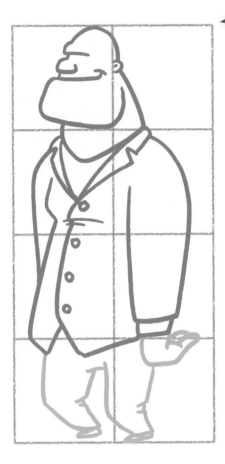

4.

Outline and shade in your henchman to suit. Here we have used a near-black on the suit that fades into blue, and then white on the highlights.

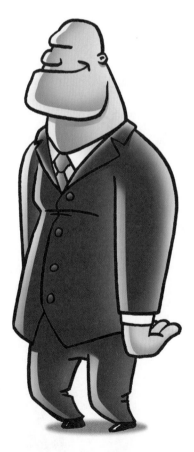

King

These rulers of the medieval world have many personalities. There was nothing more appreciated by the people than a jolly king. They dressed in large, heavy robes and often wore heavy jewelry such a larges rings on their fingers. They also carry a large golden rod called a scepter.

1.

Begin by drawing a grid with three equal squares going across and down.

Draw in the eyes followed by the nose and the mouth. Add the eyebrows to finish this stage.

2.

Draw in the big beard and the puffy material under his chin.

Draw a curved line for his stomach, which flows onto his legs. Add the other leg and his feet. Draw in another curved line going from the puffy material to the back of his hip.

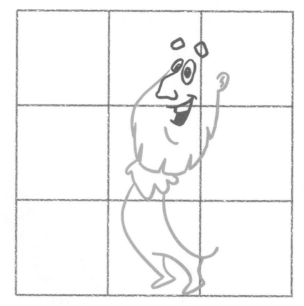

3.

Draw a curved line in front of his stomach for his robe. Add the arm and puffy robe cuff. Draw in the right hand.

Draw the other arm, cuff, and hand. Draw in a backward "S" that goes from his ear to the recently drawn hand.

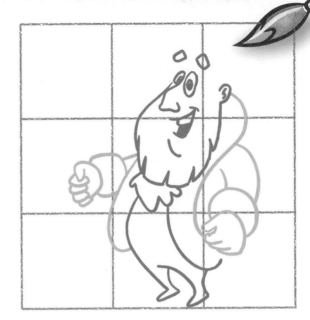

4.

Draw in the scepter and the crown. Add the spots on the robe. Draw a ring on the king's finger. Draw in the king's coat to finish this stage.

Artist Tip:

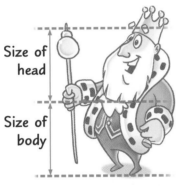

Size of head

Size of body

In cartooning, we can give our character personality by exaggerating their main features. This good-hearted king makes up in personality what he lacks in height. This personality is exaggerated by using his most expressive feature, which is his face and head. Notice how the head is as big as the rest of the body combined. The henchman in this book has a small head, because he is not very clever, but a big upper body to exaggerate his strength. The henchman's strength is the dominant feature. See if you can design cartoon characters with exaggerated attributes.

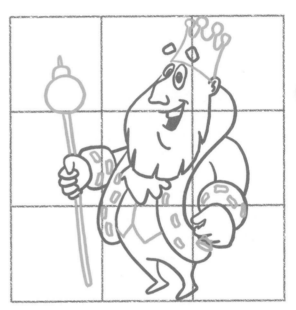

5.

Kings wore many different types robes. Red, purple, blue, and yellow are considered to be royal.

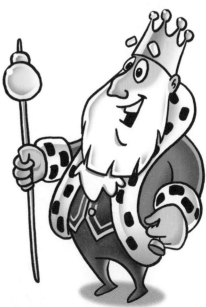

Queen

A jolly king wouldn't be a jolly king without a jolly queen. This queen was made to accompany the drawing of the king in this book. See if you can draw them side by side.

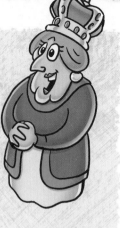

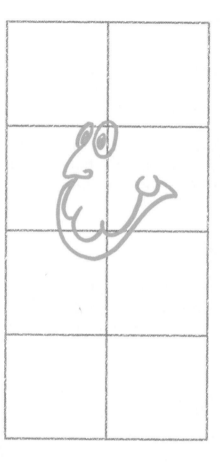

1.

Begin by drawing a grid with two squares going across and four down.

Start by drawing in the eyes and nose. Move on to the cheeks and chin. Draw in the three-quarter circle for the earring. Draw in the collar that goes from the earring to just under the nose.

2.

Add a circle for the clasped hands.

Draw in the hair shape and the upper cheek. Add the arms around to the clasped hands. Add the sides of her dress and the pattern on it.

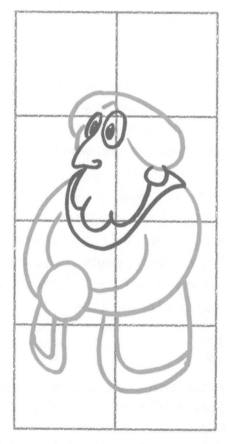

3.

Draw the crown on a slight angle. Add just a couple of eyelashes on each eye and some lines for her hair. Draw in her mouth and add the squiggly line for her fingers. Finish by drawing in the wavy line for the bottom of her dress.

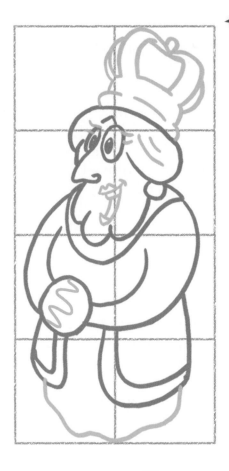

4.

Queens wear shiny crowns with bright jewels in them. Notice the white spots that highlight her crown. You can make these with correction pen or white dabs of paint.

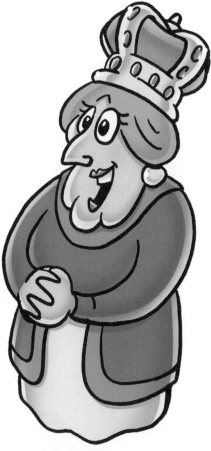

Superhero

Superheroes are a villain's worst enemy. They arrive just in time to save the day, foil the villain's evil plan, and rescue the innocent victim. Superheroes have special powers that ordinary people only dream of. Here we have a classic superhero speeding to the aid of a citizen in trouble.

1.

Begin by drawing a grid with four equal squares going across and three down.

Notice the head shape. Both the henchman in this book and this superhero have a thick neck, large chin and small forehead, which makes them look tough. A large upper body with thick arms and small legs, which we are about to draw, adds to this effect.

2.

Add the cape and the shape for the chest going in to the arm. Notice the hand is very simple. Draw in the mouth to finish this stage.

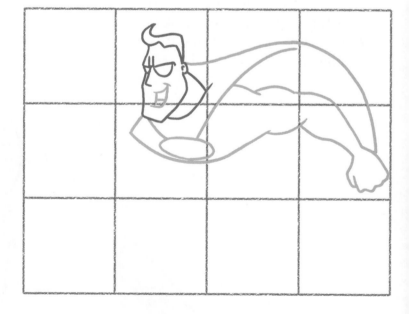

3.

Draw in the other muscular arm getting thinner as it reaches the wrist. Draw the torso getting smaller as it reaches the stomach. Add the bottom of the cape.

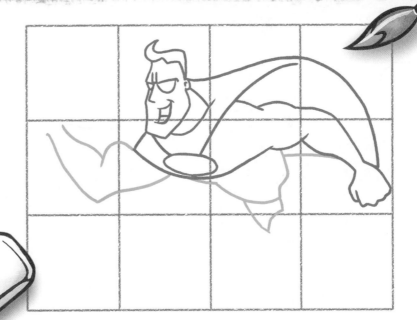

4.

Add the stomach muscle lines. As mentioned before, add the small legs. Study the clenched fist on the forward hand. Finish with the pupils in the eyes. We have left the emblem bare so you can make up your own symbol. You could even use the first letter of your name.

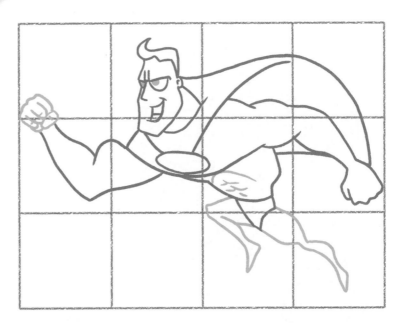

5.

Superheroes often have bright and contrasting colors and are seen in action poses. Do you think you could recreate this superhero in different poses?

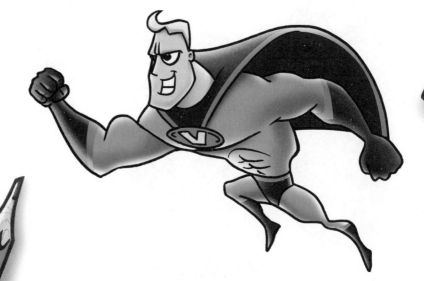

You can Draw
insects

You Can Draw
INSECTS

Contents

Ant

Ants can be found just about anywhere in the world, working together to collect food for their colony. The queen ant spends almost her whole life laying eggs. They use their antennae to smell. Ants don't have lungs! They breathe through tiny holes that they have all over their body.

1.

Begin by drawing a grid with four equal squares going across and three down.

Then draw the slightly coned shape for the head. Draw a smaller semi-circle for the middle part of the body. Add another circle behind that for the back part of the body.

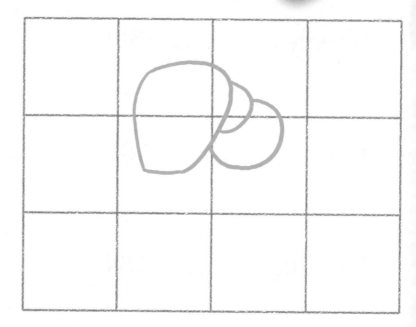

2.

Add the two eyes on the first shape and the arch at the bottom of this shape. Draw in the shapes for the legs. Check that your drawing is in the correct place on the grid before you move on.

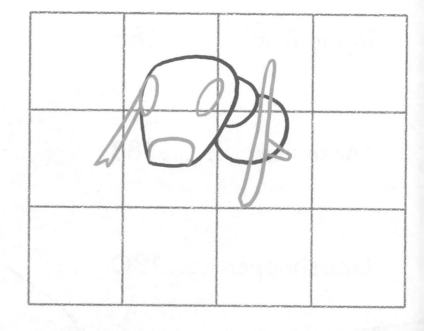

3.

Here we add the antennae and some more parts for the legs.

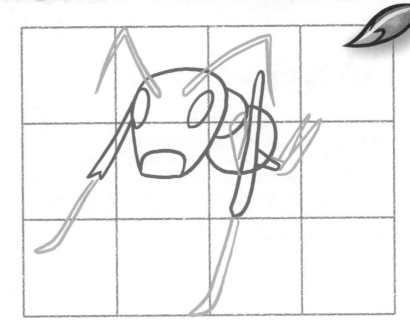

4.

Finish this drawing with the rest of the leg parts. Remember when outlining your ant to only go over the lines needed and erase all the construction lines.

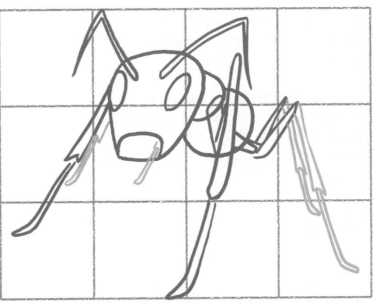

5.

Here we have a "flea's-eye-view" looking up at the ant. We thought it would be fun to take a different angle on the ant because they are very small and usually looked upon from a great height. By taking a different view, we can make something look more interesting.

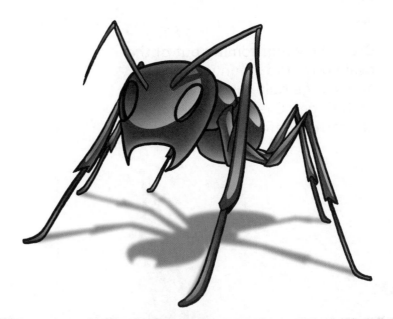

Wasp

Usually baby wasps will grow up inside a wasp nest, but some wasps lay their eggs inside other insects. That host insect will slowly be eaten by the baby wasp as it grows up. Wasps generally eat other insects, but some species are vegetarian. Watch out for this fiendish character, it has a very nasty sting!

1.

Begin by drawing a grid with three equal squares going across and down.

Now draw the two smaller eye shapes. Add the head circle behind these. Finally add the tall oval behind the head shape for the body.

2.

Draw the wings coming out of the oval body. Add a thin waist piece and a large bulb for the abdomen and stinger. Check that your shapes are correct before moving on.

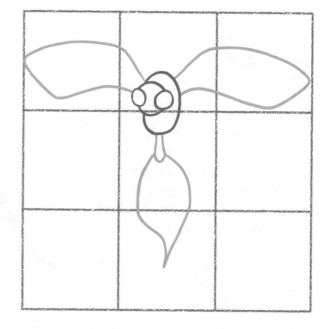

3.

Here we draw some lines (or wire-frames) for the six legs. The legs will be built around these. Draw a circle at the end of the middle set of legs for the hands. Add some lines for the wings. Finish with the details on the wasp's face.

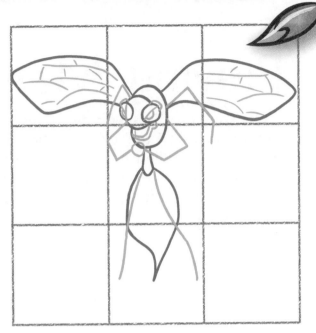

4.

Draw the top of the neck above the head shape. Add some razor sharp teeth. On the circle for the hand, add a zig-zagged line for the fingers. Build the legs in separate pieces around the wire-frame lines that were drawn in the previous stage.

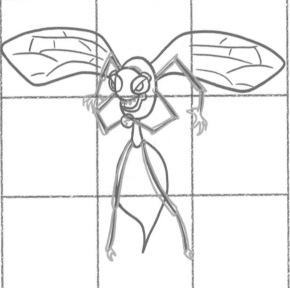

5.

Wasps are very bright and easy to see with their distinctive black and yellow markings. Did you know black and yellow are the two strongest contrasting colors?

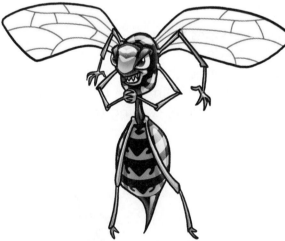

Praying Mantis

The praying mantis is a master of disguise. It camouflages itself to look like a leaf while it sneaks up on its prey. It's called a "praying" mantis because its front legs are folded in a position that makes it look like it is praying. The mantis eats other insects and sometimes even small birds!

1.

Begin by drawing a grid with four equal squares going across and two down.

Then draw a triangular shape in the top left corner of the grid. Now draw the circular shape at the other end. Join these two shapes with a line. The thin body will be based on this line.

2.

Draw shapes for eyes on either side of the triangle. Draw around the long line and smoothly join it on to the body shape, coming to a point at the rear.

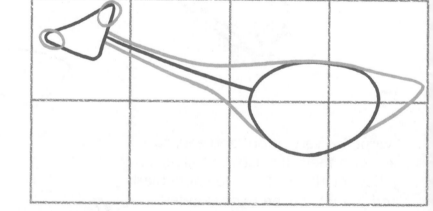

3.

Add the front leg. Draw in the middle leg and the wing.

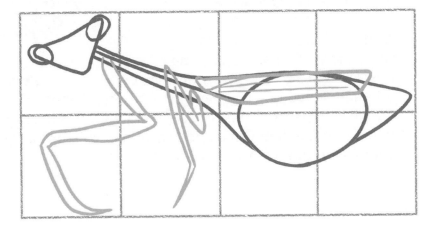

4.

Draw in the back leg and the body lines. Notice on the bottom they have been made to look slightly lumpy. Draw in the legs on the other side to finish.

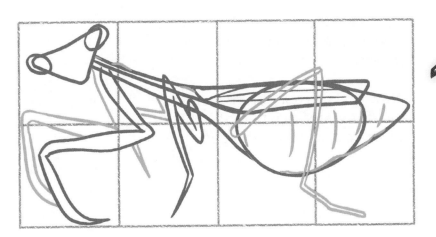

5.

The praying mantis is mostly green with a little gray on the side of its belly. You could draw it on a leaf or on a tree branch, as we have.

Ladybug

Although they are called ladybugs, there are both males and females in this species. It is very hard to tell the difference between a male and a female ladybug. They have bright backs. When they are being attacked, they ooze a yellow fluid out of their joints to make them smell and taste bad to a predator. Some ladybugs live for about two years.

1.

Begin by drawing a grid with three equal squares going across and down.

Now draw a roundish shape. Be careful to notice where the shape intersects points on the grid.

2.

Draw in some lines to divide the shape into the head and two parts of the ladybug's back.

3.

Add big eyes and feet. Draw in the large spots on the back and head to finish.

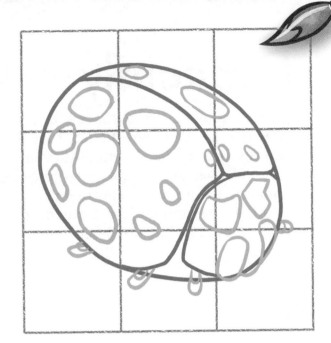

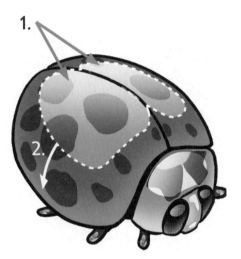

Artist Tip:

Here is a secret to great shading.

1. *The dotted lines represent the section to highlight. You can also highlight the bug's head and eyes. This part is much lighter than the rest of the bug. The highlight is stronger on one side and fades out a little at the other end.*

2. *Notice that at the edge of the highlight the red is darkest. This then fades into a brighter red, as it moves away from the highlighted section. This is the same for the body, head, and eyes.*

4.

Fill in your ladybug. Notice how there is a little bit of red and gray on the feet.

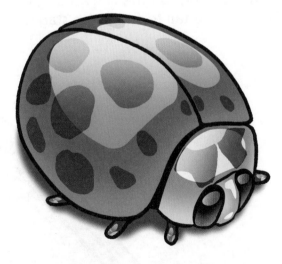

Dragonfly

Dragonflies are a flying insect and come in many different shades. They live near a source of water, where they lay their eggs. Although they are a large insect, they don't sting or bite humans. The dragonfly eats mainly smaller insects such as mosquitoes and midges. Some dragonflies can fly up to 40 miles (61 kilometers) per hour!

1.

Begin by drawing a grid with three equal squares going across and down.

Next draw the shapes for the head and the body parts. Check these are positioned in the correct place on the grid.

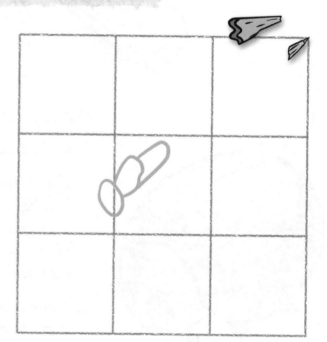

2.

Add the wings on the correct angle. Draw in the tail to finish this stage.

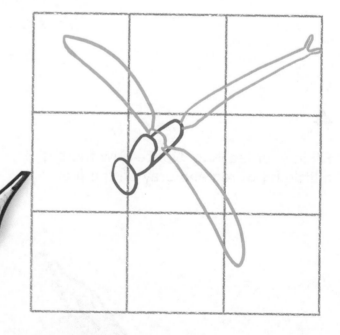

3.

Define the face by drawing in the eyes. Add the front wings and the short strokes for the legs behind the eyes.

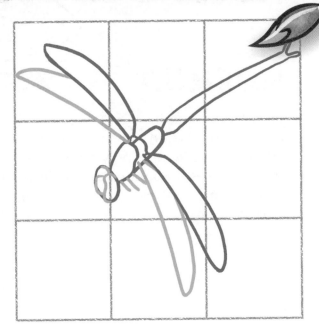

4.

Finish off by drawing the rest of the leg parts and the mouth parts.

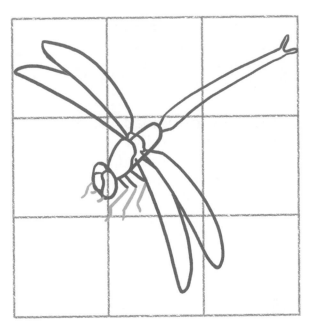

5.

Here we have added some subtle lines for the veins in the wings. Because the wings are thin, drawing these in black would have made our wings appear too dark and heavy.

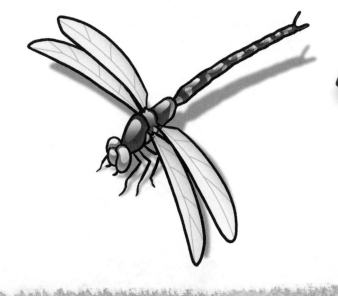

Cicada

Cicadas can spend six to 17 years underground just growing up. When they come out of the ground, the adult cicadas live for only a few weeks. The male cicada makes the loudest sound in the insect world. If you stand right next to him, he can sound as loud as lawn mower!

1.

Begin by drawing a grid with four equal squares going across and three down.

Then draw the cicada's strange shaped body and head. Check you have drawn it in the correct place on the grid.

2.

Add the shapes for the wings. Complete this stage by drawing in the eye.

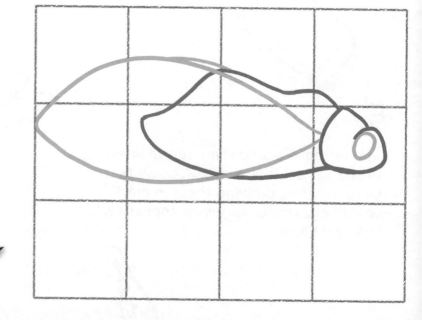

3.

Add the legs, paying close attention to how many parts there are to each leg. Draw in the small antennae.

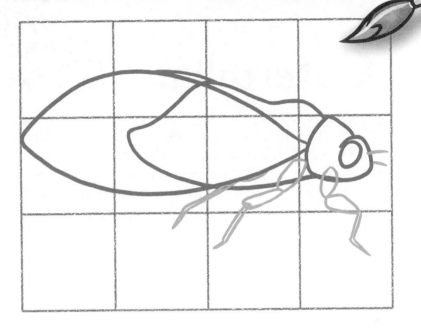

4.

Finish with the veins on the wings. When outlining your drawing, note how the back of the body line is seen through the wings. This makes the wings look transparent.

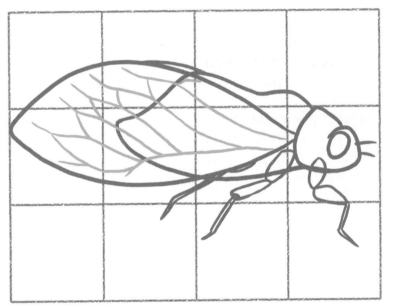

5.

This cicada has been drawn horizontally. You may like to draw the cicada vertically, as if it was hanging on to the trunk of a tree.

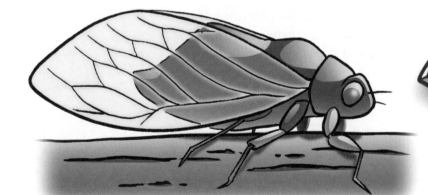

Caterpillar

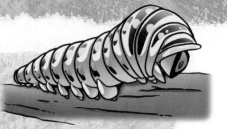

Most caterpillars have 16 legs. They have to watch out for dragonflies and birds who like to eat them. Caterpillars like to eat and eat and eat...they eat constantly and grow quickly as a result. After they finish growing, they spin a shell called a "cocoon" around them like a sleeping bag. When they're inside the cocoon, they turn into a butterfly.

1.

Begin by drawing a grid with four equal squares going across and two down.

Next draw a wobbly cone shape. Be careful to note where the shape crosses each point in the grid.

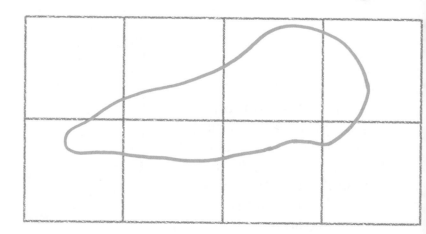

2.

Draw some curved lines that go slightly above the first shape to make it look lumpy. These curve around to form the body.

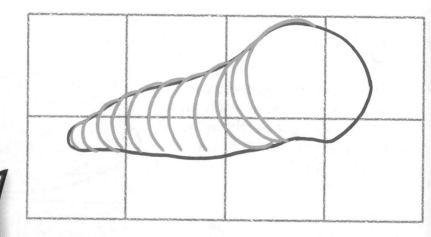

3.

Draw in the rest of the lines around the body. Add the shapes for the feet. Notice how they get smaller the further back they are on the insect.

4.

Finish with the details of the face and the lines for the tree.

Now you are ready to outline your drawing and erase the pencil lines.

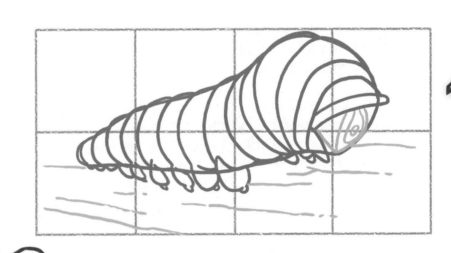

5.

Here we have the caterpillar on a tree branch. You may like to put it on a leaf that has bite marks from the insect munching on it.

Butterfly

There are about 17,000 different types of butterflies. Most adult butterflies only live for one or two weeks. Their mouth is like a straw so they can reach down into flowers and feed on the nectar. Their mouth is rolled up when they aren't eating. Some butterflies can taste with their feet!

1.

Begin by drawing a grid with four equal squares going across and three down.

Then draw a stretched semicircle and oval near the bottom of the grid.

2.

Add the shapes for the face and the eyes. Draw in the shapes for the wings to finish this stage.

3.

Add the mouth-straw at the front of the face. Draw in the legs and under-part of the body. Draw lines with arches in them on the wings.

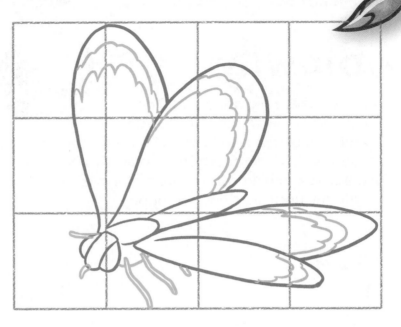

4.

Add the antennae from the top of the head. Draw in lines on the wings to meet the points of these arches drawn in the stage 3.

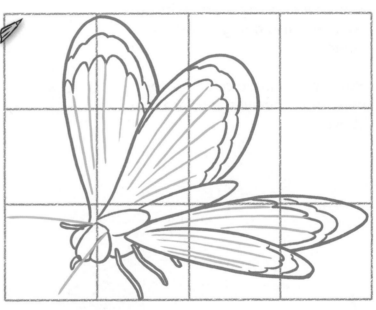

5.

Once you have outlined your butterfly, you may like to fill it in with many shades. Butterflies are one of the most decorative insects in the world.

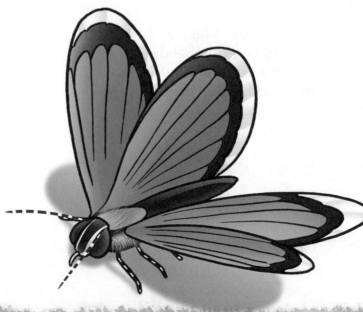

Blowfly

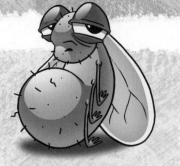

Blowflies are big noisy flies. They are commonly found at barbecues and picnics trying to land on your hot dog or swim in your drink. Other much-loved places to hang out are the garbage bin or the nearest cow pie. Blowflies are typically unclean, slow, and dopey.

1.

Begin by drawing a grid with three equal squares going across and down.

Now draw a large circle for the body. Add the eyes and face shape above it.

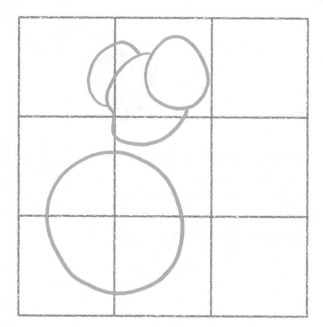

2.

Cut the eye shapes in half with a slightly curved line for eyelids. Draw in a curved line for the pupils. This makes the blowfly look dreamy. Add the rest of the body and the wings on either side.

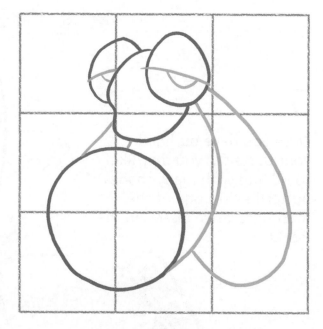

3.

Here we make the eyelids thicker by drawing slightly larger lines around the outside of the eyes. Next add the small mouth parts. Finish this stage with the thin arm and up-turned hand.

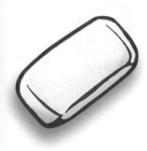

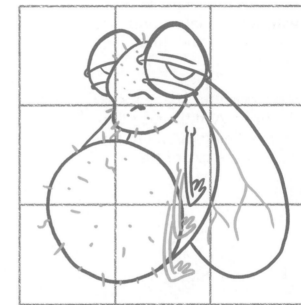

4.

Add two more sets of arms below the first set. Put in some veins on the wings. Use short strokes and dots around the body and face to make the blowfly slightly hairy.

5.

A dull, dreary blue-gray best suits a fly. This highlights the dullness and greasiness of his character.

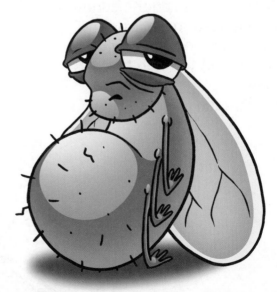

Bee

In the bee world, the queen bee is the boss. A worker bee's job is to collect nectar from flowers. They use the nectar to make honey. They all work together to get the job done. Only the female bees can sting and collect honey. The buzzing noise that bees make is their wings flapping really fast.

1.

Begin by drawing a grid with four equal squares going across and three down.

Next, draw the shape for the head. Add the next two shapes, being careful to take note of the size of them.

2.

Draw the eyes on the edges of the head shape. Add the folded antennae. Draw in the bucket to finish this stage.

3.

Here we add the arms holding the bucket. Next, draw in the legs, starting at each side of the bucket. Draw in the shapes for the wing movement. Add the highlight on the eyes to finish.

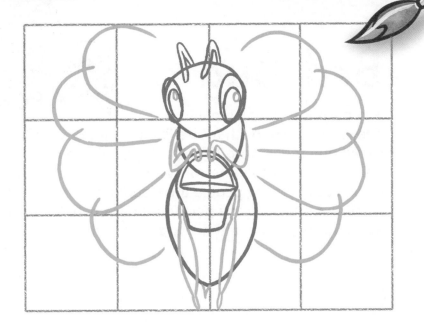

4.

Add the second set of hands and elbows near the bucket. Finish with the movement lines on the wings.

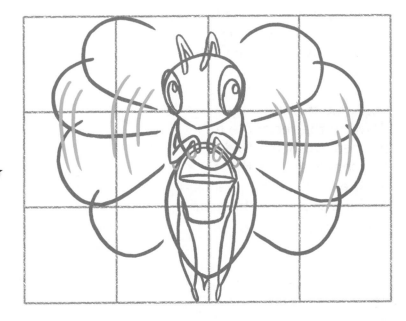

5.

To make this bee look feminine, large eyelashes have been added. This is an easy way to make something look female. Try it with your own drawings.

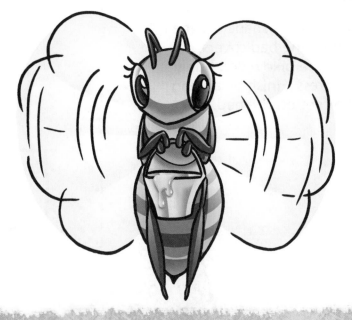

Bed Bug

Bed bugs are actually real insects. They are little bugs that bite like mosquitoes while somebody is sleeping. They don't just live in beds, but also in places like clothes or sofas. Bed bugs are rare these days because people are cleaner and wash a lot more than the average person who lived 100 years ago. Bed bug stories are often told to scare children.

1.

Begin by drawing a grid with four equal squares going across and three down.

Continue this stage by drawing the rectangle for the bed. Draw the folded bed sheets around the middle of this rectangle. Add the shape for the head and mouth.

2.

Draw in the shape for the rest of the bed covers. Add the pillow and bulgy mattress. Finish by adding the feet on the bed.

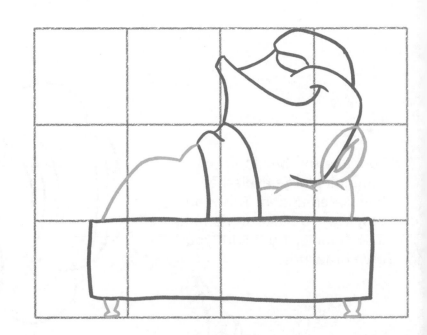

3.

Draw the teeth on the mouth and the eye. Add the shoulder and hand. Draw some ovals on the head to add character. Finish with the bedhead and the feet of the bed.

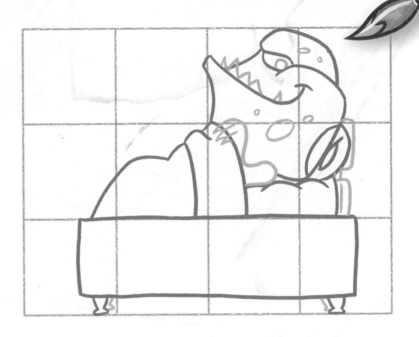

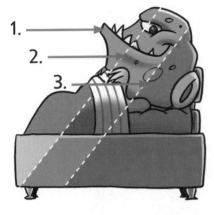

Artist Tip:

Shading can bring a drawing to life. Here is an example of stages of shading.

1. This stage has flat or solid color. There is no shading at all here.

2. Highlights and shadows are added in this stage. Highlights can be pure white or a lighter version of the flat color. We used green for the face so we would use a much lighter green for the highlights on the face. It is the same with shadows. We used a green for the face so we use a much darker green for the shadows on the face.

3. Here a darker color has been applied to show that the bug is in a dark room. Where there were greens, blues, and browns, a darker version was used over them.

4.

To make this bed bug even more dramatic, a dark background has been added with a slightly opened door. "Goodnight! Sleep tight! Don't let the bed bugs BITE!"

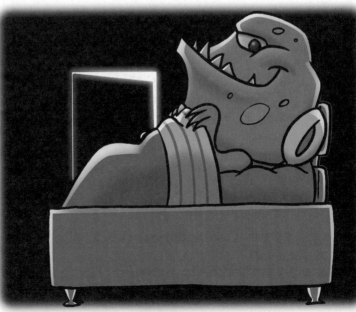

Rhino Beetle

The rhino beetle gets its name from the horns that are on its head, which are like real rhinoceros' horns. It lives in rainforests all over the world. The rhino beetle is also really strong. It can carry up to 850 times its own weight! Can you imagine how strong you would have to be to lift 850 kids just like you?

1.

Begin by drawing a grid with three equal squares going across and down.

Draw the large shapes for the head and belly. Be careful to place them in the correct position on the grid.

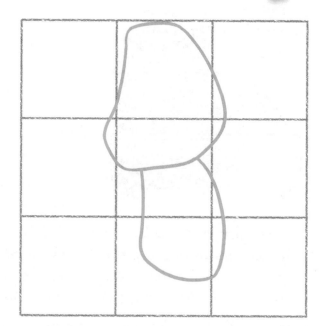

2.

Add the big curved horn. Draw in the shape on the top of his head. Draw the large curve for his shell and add the extra lines. Finish with the part of the shell on the other side of his body.

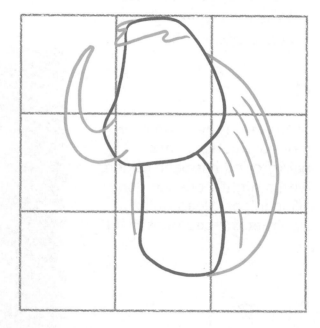

3.

Draw in the eyes. Notice how the further eye is very thin and is on the side of the head shape. Add the mouth and air puff. Draw in the curved legs to finish this stage.

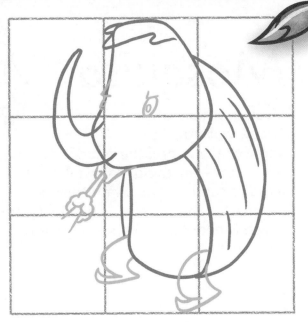

4.

Draw the hands with the dumb-bells. Add some movement lines underneath these and some sweat drips either side of the head.

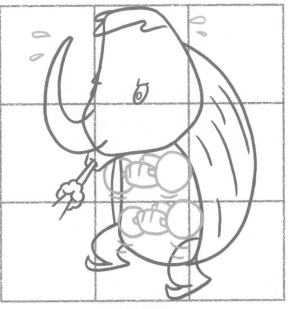

5.

Rhino beetles are very dark, so try to choose a shade that is dark but doesn't block out your black outlines.

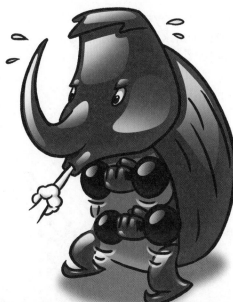

Mosquito

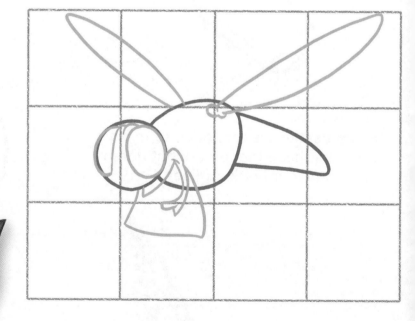

Mosquitoes are attracted to sweat, warmth, light, and the air we breathe out of our lungs. They breed in still water – anything from still creeks to puddles. Only the females can bite and when they do, they leave little, itchy red marks. They also have an annoying buzzing sound, which is heard after you turn your bedroom light off.

1.

Begin by drawing a grid with four equal squares going across and three down.

Next, draw the shapes for the head, body, and tail. Check to make sure you have them in the correct places on the grid.

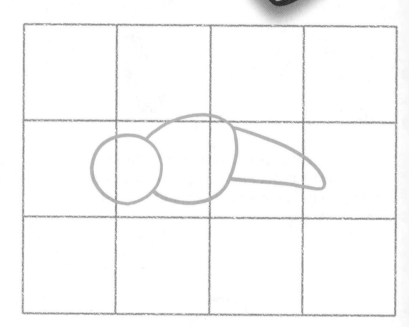

2.

Draw in the eyes and mouth. Add the napkin. Draw in the wings to finish this stage.

3.

Draw in the swirl on the large eye. Add the eyelid for the other eye. Draw in the snout and circles at the base of the eye. Draw the hairs on the back. Finish with the lines on the wings.

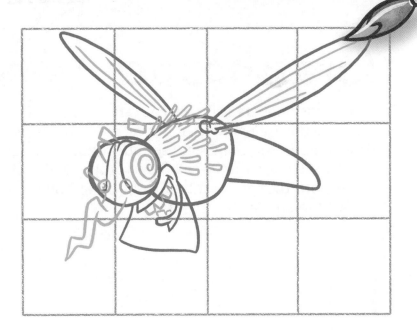

4.

Draw the front legs with the hands and cutlery. Add the pupil in the further eye. Draw the rest of the legs on both sides. Add some rings around the tail to finish.

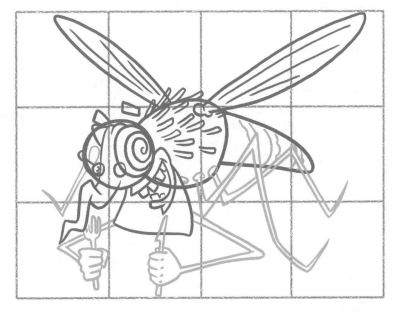

5.

Mosquitoes are a menacing insect. What better way to capture this characteristic than with a menacing looking mosquito. Good thing they're easy to swat, huh?!

Grasshopper

Some grasshoppers will only eat certain types of leaves, while others will eat almost any type of plant. Grasshoppers sometimes eat so much that a farmer can lose all the crops that he has been growing. Grasshoppers can fly, but they are best known for their ability to jump really high and far for their size.

1.

Begin by drawing a grid with four equal squares going across and three down.

Study these shapes carefully in order to recreate them on your own grid. Begin by drawing in the head, eye, and mouth shapes.

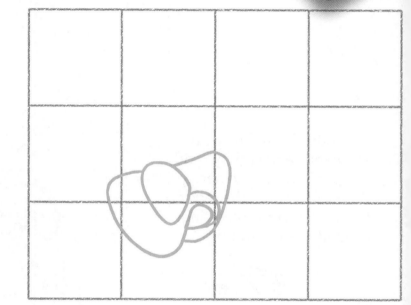

2.

Draw in some lines for the eyelids and the eyeballs. Add the eye shape on the other side of the head shape. Draw the wings and add the lines for the underbelly of the grasshopper.

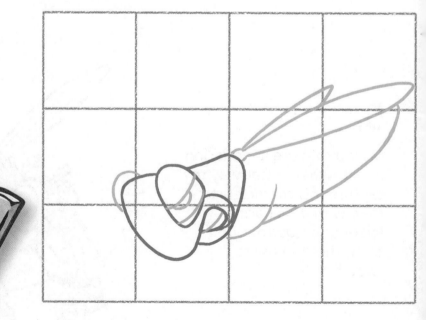

3.

Draw the similar two front legs and their shoes. Draw in the large back leg and shoe to match.

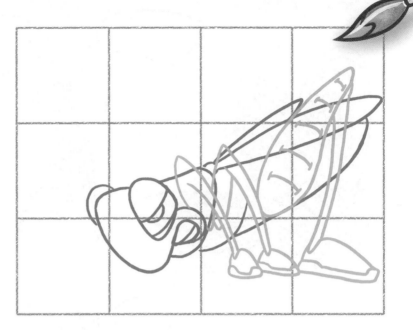

4.

Add the antennae on the head. Draw the legs and shoes on the opposite side. To finish, define the laces on the shoes.

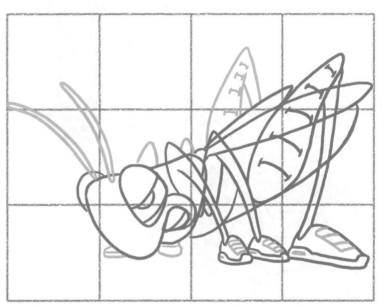

5.

Because grasshoppers can jump so far, we thought it would be fun to enter ours into the Cartoon Insect Olympics. What other insects can you think of to join in these games?

LONGJUMP COMPETITION

Published by Hinkler Books Pty Ltd
45–55 Fairchild Street
Heatherton Victoria 3202 Australia
www.hinkler.com.au

hinkler

© Hinkler Books Pty Ltd 2006, 2014
Written and Illustrated: Damien Toll, with thanks to Jared Gow
Cover Design: Sam Grimmer
Prepress: Graphic Print Group

ISBN: 978 1 7436 3124 9
Printed and bound in China